WITH LOVE

HarperCollins books may be purchased for educational, business, or sales promotional use. For information, please write: Special Markets Department, HarperCollins*Publishers*, 10 East 53rd Street, New York, NY 10022.

FIRST EDITION

First published in 2008 by:
Collins Design
An Imprint of HarperCollins*Publishers*
10 East 53rd Street
New York, NY 10022
Tel: (212) 207-7000
Fax: (212) 207-7654
collinsdesign@harpercollins.com
www.harpercollins.com

Distributed throughout the world by:
HarperCollins*Publishers*
10 East 53rd Street
New York, NY 10022
Fax: (212) 207-7654

Design by Agnieszka Stachowicz

Library of Congress Control Number: 2007933761

ISBN: 978-0-06-144150-9

Printed in China
First Printing, 2008

With Love

ARTISTS' LETTERS AND ILLUSTRATED NOTES

LIZA KIRWIN WITH JOAN LORD

Archives of American Art, Smithsonian Institution

COLLINS | DESIGN

An Imprint of HarperCollinsPublishers

Contents

Foreword

One of the great strengths of the Archives of American Art is the ability, through its unparalleled collections, not only to enlighten the grand narrative sweep of American art history, but simultaneously to add human faces and voices to its vast cast of characters. Through diaries, journals, personal correspondence, and candid photographs, our collections provide rare and deeply affecting insight into the lives of individual artists, from their professional successes and failures to their personal struggles and joys.

In this compelling volume of letters drawn from our collection, Liza Kirwin, the Archives of American Art's gifted curator of manuscripts, has perused thousands of letters to find those that address the subject of love in all of its infinite varieties, from passionate longing to playful flirtation, maternal devotion to platonic affection. My thanks to Liza and to archives specialist Joan Lord for bringing their own passion

and love for our collections to bear on this book.

On behalf of the Archives of American Art, I would like to acknowledge the many people who generously gave of their time and expertise toward the realization of this project. We are deeply grateful to our Smithsonian colleagues for their insightful contributions, particularly Frank H. Goodyear, assistant curator of photography, National Portrait Gallery; George Gurney, deputy chief curator, Smithsonian American Art Museum; Rosemary Regan, editor, Office of Exhibits Central; Cathy Keen, archivist, Archives Center, National Museum of American History; Cecilia Chin, librarian, Smithsonian Museum of American Art and National Portrait Gallery Library; and our senior research fellow, Jonathan Katz.

Among the dedicated and knowledgeable staff of the Archives of American Art we wish to thank intern

Anna Bordelon, for retrieving documents and helping with the tricky transcription of handwritten letters, and acquisitions specialist Laura MacCarthy, for her swift and expert research assistance. We appreciate Marv Hoffmeier's technical expertise with digital imaging and quick response to our many requests. Other Archives staff who contributed significantly to the project are Marisa Bourgoin, Wendy Hurlock Baker, and Elizabeth Botten in our reference department, and archivists Erin Corley, Jean Fitzgerald, Cathy Gaines, and Megan McShea.

To the numerous individuals who provided information and granted permissions to publish items from the Archives, we are especially grateful. These include Patricia Albers, Jim Arkatov, Maryette Charlton, Ken Clark for the Dale Chihuly Archive, Royce Dendler, Charles Faulhauber, Salomon Grimberg, Wesla Hanson, Helen A. Harrison of the Pollock-Krasner House & Study Center, Jon Ippolito, Mimi Mara Levitt, Lisa Ponti, Steye Raviez, Cynthia Dufrey Smith, Carolyn Somers for the Joan Mitchell Foundation, Lenore Tawney, and Patti Warashina.

We also thank Elizabeth Viscott Sullivan, senior editor at Collins Design, for her enthusiastic direction of this project.

We're also deeply appreciative of the creativity and hard work of art director Ilana Anger, designer Agnieszka Stachowicz, and managing editor Dinah Fried.

Finally, we respectfully dedicate this volume to the countless artists, collectors, critics, dealers, and arts organizations who over the years have so generously donated their papers to the Archives of American Art. May Eros be with you!

—John W. Smith
Director, Archives of American Art

Introduction

Love letters bring out the voyeur in most of us. These deeply personal communications have the power to make us blush or, at the very least, to let us observe a tender moment in the complex lives of others. This selection of forty affectionate communiqués to and from American artists gives us insight into the lives of painters, sculptors, illustrators, and others—their relationships, perceptions, and creative energies—from the mid-nineteenth to the late twentieth century. These letters also allow us to empathize with artists through the most universal of human emotions—love in all its permutations. The correspondence included here represents a range of intensity, from sexual passion to parental devotion and from the durable bonds of friendship to the enthusiasm of fans.

"God you mean a lot to me," wrote painter Joan Mitchell to fellow abstract expressionist Michael Goldberg. In a gesture that could only come from an artist in love, she added, "I'm using the paint off your palette—I feel so close to you." Artists do have a special way of relating to the world. Dennis Miller Bunker, a lovesick painter in Paris, wrote to his fiancée, "I truly do nothing but wander about in a shabby coat with a palette in my hand & lovely Eleanor in my heart." When master draftsman Kenyon Cox penned a poem to his wife, Louise, he cast her as the living, breathing embodiment of sculptures he had loved. The Coxes courted through correspondence. After eight years of letters, they married in 1892.

In the days before e-mail, "snail mail" was a practical and romantic way to woo someone, and its hands-on nature added significance for both artist and lover. The amorous correspondent would compose a handwritten letter on paper, fold it, insert it in an envelope, seal it, address it, add a stamp, and send it on a circuitous postal route, often over great distances and through hazardous conditions. The recipient

I kiss you a thousand times my darling love.

——Dennis Miller Bunker to Eleanor Hardy, ca. 1890

♥ ♥

would then open the private packet, unfold the enclosed paper to feel its weight and texture, trace the handwriting with its unique qualities of line and pressure and spacing, linger over each word, and breathe the scent of a handmade communication. He or she might then refold the letter and place it in a pocket near the heart to be read again and again.

Emotionally charged and highly evocative, a love letter was the next best thing to being with the person. When Mexican surrealist Frida Kahlo received a letter from her lover Nickolas Muray, she wrote, "Your words made me feel so close to you that I can feel near me your eyes—your hands—your lips. I can hear your voice and your laugh…. I am just counting the days to go back. A month more! And we will be together again."

The torturously slow exchange of letters created a depth of longing and desire. Painter Walter Gay wrote, "Every time the *Facteur* [mailman] comes, I have met him with a beating heart, only to be disappointed…. Even one day without hearing from you, is misery." When caricaturist Alfred Frueh was in Europe in 1912 and 1913, he wrote more than two hundred illustrated letters to his fiancée, Giuliette Fanciulli, in New York. He constantly begged for the letters she wrote on pink paper, which he called "pinkies" or "Ps." "I would sooner have the 'pinkies' than the 'blues,'" he cried. "Weeks without 'Ps' are as empty as cream puffs without cream."

These artists, with their palpable heartaches, illustrate Shakespeare's adage that the course of true love never did run smooth. When Joan Mitchell wrote to Michael Goldberg, he was spending six months at the Rockland State Hospital in Orangeburg, New York, in lieu of serving prison time for writing fraudulent checks drawn from her husband's account. It is no wonder that Joan was drinking bourbon at night with her upstairs neighbor, painter Philip Guston.

She lamented, "*Quiero morir* [I want to die]—but I won't…. I will sleep now—maybe—it used to be so easy—and the cot is filled with you."

Painter Nancy Douglas Brush wrote to her fiancé and fellow art student Robert Pearmain, begging him not to postpone their wedding: "I <u>must</u> be your wife no matter how hard life may come to us." Robert had severe doubts about his earning power as an artist, but Nancy insisted, "I wish to share hardships with you." While they did marry on the set date, in September 1909, Nancy's vow about sharing hardships was sadly prophetic—Robert died of leukemia just three years later.

The letters include a range of responses to the vicissitudes of love. Joseph Lindon Smith flatly declared, "…we shall be happy beyond all <u>words of expression</u>," while Bunker tempered his bliss with reality: "Will you love me when I am stupid and cross, when I fail and make mistakes and I worry you with my doubts."

The love between friends and between parent and child are presented in this volume. Artists Italo Scanga and Dale Chihuly, who met in 1967, were fast friends and artistic collaborators until Scanga's death in 2001. They kept in near-constant contact by sending faxes. They called each other "brother." Theirs was a relationship as strong as blood.

In the summer of 1940, social realist painter Moses Soyer sent sweet illustrated letters and notes to his son David, who was away at summer camp. Though Soyer himself was not a major baseball fan, he catered to his son's interests by including news of the New York Giants' winning streak. In 1859, Sarah Baldwin Warner wrote a tender dispatch to her young son Olin Levi Warner when he was away at school: "…my thoughts often wander to the place where we believe you are trying to get an education and we feel quite sure you will try to improve the precious hours God gives you…." Her loving admonitions about hard work and education paid off in a way she

probably did not expect: Olin later became one of the first American sculptors to study at the École des Beaux-Arts in Paris.

Fan mail expresses perhaps the most idealized form of love, since the sender rarely knows the recipient but admires him from afar. The glamorous and seductive film star Hedy Lamarr, who received tons of fan mail herself, wrote a flattering note to abstract expressionist Franz Kline: "When I first saw one of your paintings…I had to sit down because it did something to me." No doubt, Lamarr's gut reaction pleased Kline.

While many of the selected love letters were carefully composed, others contain crossed-out phrases, tangled rushes of words, emotional tensions, personal flourishes, odd enclosures, and charming illustrations that connect present-day readers with the artists/writers in a direct and visceral way. Painter Frank Vincent DuMond made inky thumbprints on his letter to his fiancée; Waldo Peirce embellished a racy poem with animated watercolors; and Frida Kahlo sealed her passionate prose with fuchsia lipstick kisses.

There are also the idiosyncrasies of lovers who communicate through pet names—Teeky, Piepet, Spiggy—and innuendo. "I Love Mrs. Bubby," wrote the married Waldo Peirce to his friend Sally Davis, "Her breasts are so firm/If I don't meet her hubby/ They'll do me no harm."

More often love letters go straight to the heart of the matter. Painter and illustrator Rockwell Kent wrote to his beloved Frances: "To see you, hear you, touch you, is now the only happiness, the only life I know."

These letters speak to us as they did to their original recipients, allowing present-day readers to connect with the lives and loves of artists across time and space. They give clues to the artist's biography and personality as well as details of romantic attachments. They make us appreciate the power of handmade communications to convey something unique of the sender.

—Liza Kirwin

The Letters

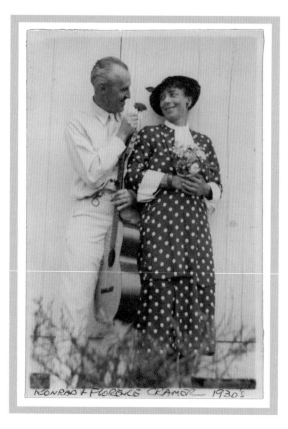

KONRAD + FLORENCE CRAMER 1930's

FLORENCE BALLIN

(1884–1962)

♥

KONRAD CRAMER

(1888–1963)

"Oh my beloved"
Do you not hear my heart
calling you!

Konrad Cramer was born in Wurzburg, Germany, and trained in the Karlsruhe Academy of Fine Arts. He met American painter Florence Ballin in the romantic setting of a *bal paré* (full-dress ball) in Munich on February 25, 1911, when she was touring Europe. They fell head over heels in love, continued their courtship through correspondence, and married in London four months later. They moved together to America in 1912, settling in Woodstock, New York, in the 1920s, where they worked and collaborated together for the rest of their lives.

Konrad, who had been steeped in the Munich avant-garde, especially engaged with the ideas of Franz Marc and the Blaue Reiter group, was one of America's first abstract painters. Florence studied at the Art Students League and, with her husband, was an early member of the Woodstock Art Association.

LEFT: Konrad and Florence Cramer, ca. 1930. Photographer unknown. Konrad and Florence Ballin Cramer papers, 1897-1968.

BOTTOM: Florence Ballin in her studio at 30 West 59th Street, New York City, ca. 1905. Konrad and Florence Ballin Cramer papers, 1897-1968.

RIGHT: Florence Ballin to Konrad Cramer [1911]. 1 page. Konrad and Florence Ballin Cramer papers, 1897-1968. TRANSCRIPTION ON PAGE 100.

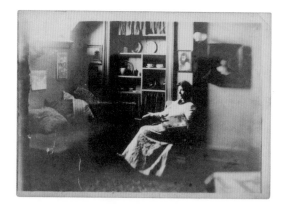

"Oh my beloved" Do you not hear my
heart calling you? I lay awake long hours
thinking last night, and then I dreamed
again, a strange dream. It is long
since I have had sleeping dreams, the waking
ones I am never without. I still felt as if
it would all suddenly melt away, this
great happiness - but it must not dear
heart, it would be too cruel and I do not
want to suffer so.

Come and let me look at you and know
that it is real - That I am Florence Ballin
and you are my dear Comrade, my
sweet playmate and not some magic
person who might his appear at any moment

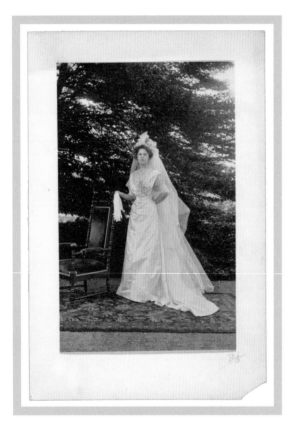

GIFFORD BEAL

(1879–1956)

♥

MAUD RAMSDELL

(1889–1968)

Gifford Beal developed a solid reputation in the early twentieth century for his impressionist paintings of circus performers and garden parties. As a boy of 12, he studied with William Merritt Chase, and after graduating from Princeton in 1900, he attended the Art Students League of New York. He served as the president of the League from 1916 to 1929.

In 1906, when he wrote to his fiancée, Maud Ramsdell, he was just an up-and-coming artist. She was at the Star Ranch in Comstock, Texas, near Del Rio, and he was in New York City, thinking of traveling north to his family home in Newburgh, New York, to paint snow scenes. He wanted to paint the morning light on the snow-covered hills, but found it difficult to wake early enough to catch the sunrise. He drew a sketch of himself sound asleep at 8:00 A.M. In his longing for Maud, he took out a map of the United States, found her exact location, and began to plot the quickest route to Texas. They married in 1908.

LEFT: Maud Ramsdell Beal on her wedding day, 28 May 1908. Photographer unknown. Gifford Beal sketches, sketchbooks, and papers, 1902-1953.

RIGHT: Gifford Beal to Maud Ramsdell, 19 December 1906. 5 pages. Gifford Beal sketches, sketchbooks, and papers, 1902-1953. TRANSCRIPTION ON PAGE 100.

I look at the map so eagerly and it seemed to bring you very near me Sweetheart.

8 A.M.

part of the state I expected it to be.
I look at the map so eagerly and
it seemed to bring you very near
me Sweetheart.

I find that I can take the
Mallory Line to Galveston and
get to Del Rio by a very direct
route right across the state. I
will probably be with Albert part
of the way as he is fond of the
sea trip and is counting on
going to Mexico. He makes a
fine travelling companion and we
get along famously together.
You will probably get this letter
just about Christmas

Good night Sweetheart
I long to see you again I hope it
With all my love (does not look
offensive)
Sifford (Pun)

Please excuse blots in middle of this letter

Dec 19. 1906
1 WEST 121ST. STREET.

Dearest Girl
Father has
just returned from Newburgh
and says that it was snowing
hard up there this morning; although
it has been raining here all day.
So I think if that is so I will go
up there soon because I want to
get some snow scenes. The High-
lands are so beautiful in this
kind of weather; I mean when the
hills are covered with snow. I want
most of all to get early morning
effects when the sun is just
rising and the light is touching
the tops of the hills. The worst part
of it is I am such a late riser
in the mornings. It is very bad for

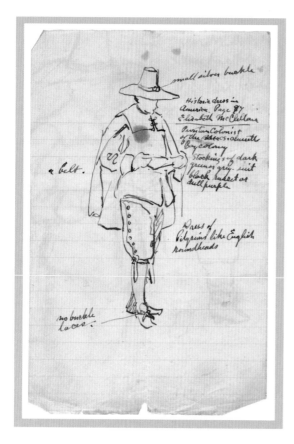

In 1912, painter Max Bohm sailed from France on the SS *Rochambeau* to the United States to install his mural *New England Town Meeting* in the law library of the Cuyahoga County Courthouse in Cleveland, Ohio. Born in Cleveland, Bohm spent most of his painting career in Europe. On this transatlantic crossing, news of the sinking of the *Titanic* on April 15, 1912, reached the *Rochambeau*. Bohm's letter to his wife, Zella, who remained at their home in Paris, is charged with his longing to see her and their children in the wake of this disaster. He writes: "Now you dear Teeky don't worry but say a prayer for your Pa Pa. Do not worry!!! I wish you were all with me. It would be a comfort but I am now going to do the best that I can for you all." Bohm had tried to sail on the *Titanic*, but was unable to get a ticket.

LEFT: Max Bohm's *New England Town Meeting* sketchbook, ca. 1912. 18 pages. Max Bohm papers, 1856-1964.

RIGHT: Max Bohm to Zella Newcomb Bohm, 19 April 1912. 7 pages. Max Bohm papers, 1856-1964. TRANSCRIPTION ON PAGE 101.

MAX BOHM

(1868–1923)

♥

ZELLA NEWCOMB BOHM

(1870–1956)

I am quite miserable because I would like to take the next steamer back to you and cant do it. I have you and the children before my minds eye all the time....

À Bord S.S. Rochambeau

le 12 Friday April 1912

My Dear Teeky Teeky Darling

We have been nearly a week now and we have had pretty bad weather all the time with most people sea sick and I did not escape it either. I fought against it and treated but I had to go like the rest, but it was bad only one day and I only missed one meal having been forced to leave the table. We made up a table of those people whom you saw

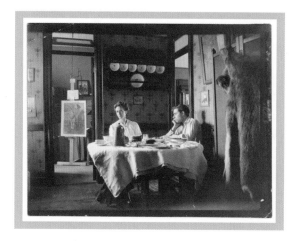

PAUL BRANSOM

(1885–1979)

♥

GRACE BOND

(ca. 1885–1963)

Nothing short
of a team of horses
& a log chain—will be able
to persuade me to leave
before your train comes in.

Paul Bransom, known as the dean of animal artists, developed his talent through on-the-job training. At 14, he apprenticed with a draftsman at the U.S. Patent Office in Washington, D.C., and then worked briefly as a draftsman for the Southern Railroad and General Electric. At 17, he moved to New York City to seek his fortune as an artist. *The New York Evening Journal* hired him to carry on Gus Dirk's comic strip, "The Latest News from Bugsville," which Bransom wrote and illustrated from 1904 to 1907.

In 1905 he fell in love with actress Grace Eliza Bond. When Bransom wrote to her in October of that year, she was in Washington, D.C., with the Fritzi Scheff Company performing in the comic opera *Mlle. Modiste*. Bransom was engrossed in George du Maurier's romantic novel *Trilby*, about a girl working as an artists' model in bohemian Paris, where she encounters a character named Svengali, who hypnotizes her and transforms her into a great diva. Bransom wrote, "I never tire of it—& I'm going to read it to you (minus the French) during the cozy long winter evenings we shall be together." They married on January 31, 1906. That same year Bransom sold five covers to the *Saturday Evening Post*, launching his career as a freelance illustrator.

TOP: Grace and Paul Bransom in Saratoga, New York, ca. 1915. Photographer unknown. Paul Bransom papers, 1862–1983.

BOTTOM: Paul Bransom sketching a leopard in Hollywood, California, ca. 1928. Photographer unknown. Paul Bransom papers, 1862–1983.

RIGHT: Paul Bransom to Grace Bond [1905]. 2 pages, illustrated. Paul Bransom papers, 1862–1983. TRANSCRIPTION ON PAGE 102.

Thursday -

TRILBY!!!
TOUJOURS-AMOUR

My Gracie -

You had better not be a wreck by
the time you reach Wash - (which I think
it will be by the time you leave).

I'm so glad Nora approves - Of
course I was very anxious over the effect
of our interview + was so worried for
fear she would not - I will be at
the station at 8 o'clock Sunday morning -
+ I'm sure - nothing short of a
team of horses + a log chain - will
be able to persuade me to leave before
your train comes in - Having been
reading Trilby again today - I was

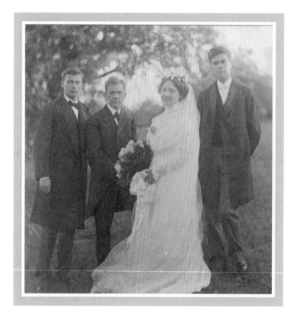

NANCY DOUGLAS BRUSH

(1890–1979)

♥

WILLIAM ROBERT PEARMAIN

(1888–1912)

For painters Nancy Douglas Brush and William Robert Pearmain, the course of true love did not run smooth. Robert and Nancy were childhood neighbors in the artists' colony of Dublin, New Hampshire. In about 1906, when the Brush family moved to Florence, Italy, to work and study art, Robert dropped out of Harvard and followed them, to the distress of his parents. In Italy he became and a student of Nancy's father, painter George de Forest Brush; he also became engaged to Nancy. In 1909, the Brushes returned to Dublin, and Robert rejoined his family in Framingham, Massachusetts, where quarrels with his father amplified his financial insecurities. "I am somewhat scared about our future just this moment," he wrote to Nancy. "I want your advice very quickly on what we'd better do." Nancy had no doubts. She begged him not to postpone their wedding: "Robert, let us undertake supporting ourselves no matter how hard rather than not to get married after all this waiting!" They married at the Brush farm in Dublin, New Hampshire, on September 11, 1909. Robert became an assistant to muralist Barry Faulkner. Sadly, he died of leukemia in 1912.

Darling, I must be near you and live with you!

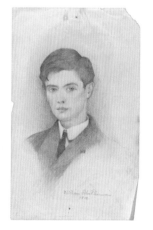

TOP: The wedding party, *from left to right*: Gerome de Forest Brush (Nancy's brother and the best man), George de Forest Brush (Nancy's father), Nancy Douglas Pearmain, and William Robert Pearmain, 11 September 1909. Photographer unknown. Nancy Douglas Bowditch papers, ca. 1900s–1970s.

BOTTOM: Drawing of William Robert Pearmain by Nancy Douglas Pearmain, 1912. Graphite, 1 page. Nancy Douglas Bowditch papers, ca. 1900s–1970s.

RIGHT: Nancy Douglas Brush to William Robert Pearmain, 17 August 1909. 4 pages. Nancy Douglas Bowditch papers, ca. 1900s–1970s. TRANSCRIPTION ON PAGE 102.

Dublin, New Hampshire.

August 17th 1909

Dearest Robert —

Alas I have received your
bad news letter! The only
one I have had since you went
away and it now makes me feel
that I wish you had never
gone away. But I'll tell you
one thing, dear Robert, that
I feel perfectly calm and quiet
in my mind and can tell you
just what I think we'd better
do. Get married on September
the 11th, and I'll tell you why.
You know that I am not
over happy in my family

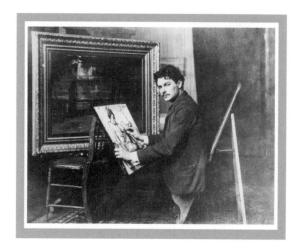

DENNIS MILLER BUNKER

(1861–1890)

♥

ELEANOR HARDY

(1869–1953)

In late 1889, painter Dennis Miller Bunker's temporary separation from his fiancée Eleanor made him lovesick. He wrote to her at her family's home in Boston, "I truly do nothing but wander about in a shabby coat with a palette in my hand & lovely Eleanor in my heart." For emphasis he set off the words, "I love you so just now that I can't breath," in an ink-drawn box. A student of William Merritt Chase and Jean-Léon Gérôme, and a friend and contemporary of John Singer Sargent, Bunker painted lush impressionist landscapes and sensitive portraits. He and Eleanor married in October 1890 and settled into the Sherwood Studio Building in New York City. Sadly, Bunker, who showed such great promise as a painter and had just begun his life with Eleanor, died two months later of spinal meningitis at age 29.

LEFT: Dennis Miller Bunker in his studio, after 1883. Photographer unknown. Dennis Miller Bunker papers, 1882-1943.

BELOW AND RIGHT: Dennis Miller Bunker to Eleanor Hardy, ca. 1890. 11 pages. Dennis Miller Bunker papers, 1882-1943. TRANSCRIPTION ON PAGE 103.

I love you so just now that I can't breath.

I kiss you a thousand times my darling love

Your marvellously accurate
dream about me the other
day, is peculiarly applicable
just now — for I really
[I kiss you a thousand
times my darling love]
do nothing but wander
about in a shabby coat
with a palette in my
hand, and a lonely
shadow in my heart.
Platt my neighbor is
amazed at the amount
of time I can spend
doing nothing, just as
if thinking of you were
an unimportant occu-
pation. no one to be in
any way hurried?

I assure you my beloved
that I don't hurry.
I must stop writing
now. I will tell you
when I am coming
just as soon as I know
myself. will you be
glad to see me? —
my own dear love, think
of this of me — I send you
a million kisses — I
haven't much love left
over — but will you give
what there is to your
mother and sister?
Send me a letter as soon
as you can get me
written — I love you sweet
Denis.

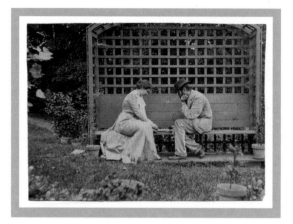

KENYON COX

(1856–1919)

♥

LOUISE COX

(1865–1945)

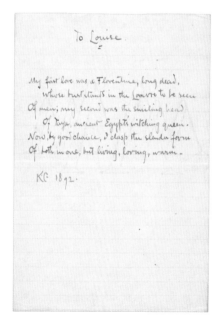

Kenyon Cox met his future wife, Louise Howland King, in 1884 when he was the instructor of her life drawing class at the Art Students League of New York. He was a master draftsman and a stern teacher; she was a serious student.

In her memoir Louise wrote, "I remember well the first impression of Mr. Cox. The class sat in a semi-circle facing the door he was to enter. His reputation as a ruthless critic was thoroughly established so we were excited and a little in awe of our new instructor; therefore when the door opened quietly and a tall, slender, slightly stooped, bearded man of about thirty took his place before us it did not seem possible that it could be the severe caustic individual we feared."

Cox did reduce his weaker students to tears, but Louise ascended to the top of the class. They began a slow, meandering courtship that culminated in marriage on June 30, 1892. That same year he penned a poem to her, "To Louise," casting her as the living, breathing, bewitching embodiment of sculptures he had loved.

TOP: Kenyon and Louise Cox playing checkers, ca. 1895. Photographer unknown. Allyn Cox papers, 1870-1982.

BOTTOM: Kenyon Cox poem, "To Louise," 1892. 1 page. Kenyon and Louise Cox papers, 1876-1977.

RIGHT: Kenyon Cox teaching a life drawing class at the Art Students League, New York, ca. 1890. Photographer unknown. Allyn Cox papers, 1870-1982.

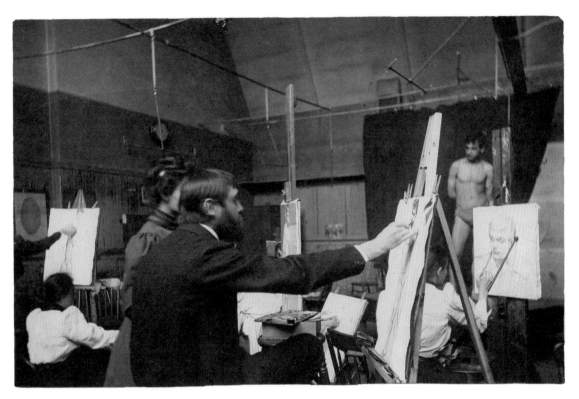

To Louise

My first love was a Florentine, long dead,
　　　Whose bust stands in the Louvre to be seen
Of men; my second was the smiling head
　　　Of Taya, ancient Egypt's witching queen.
Now, by good chance, I clasp the slender form
Of both in one, but living, loving, warm.

KC 1892.

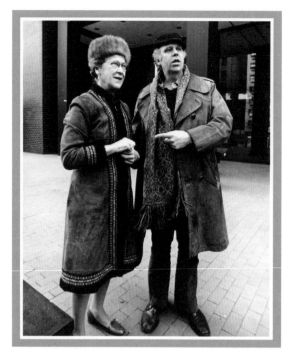

ROYCE DENDLER

(b. 1941)

♥

ELLEN HULDA JOHNSON

(1910–1992)

Artist Royce Dendler and art historian Ellen Hulda Johnson shared a fascination for psychic phenomena and the occult. They met when Dendler was teaching at Oberlin College in Ohio, between 1966 and 1970. Johnson's professional association with Oberlin began in 1939 and ended with her retirement from teaching in 1977. They kept in touch through letters and the odd enclosure.

Around 1971, Dendler sent Johnson a "love charm"—a single flower petal inside a small stoppered vial wrapped in blue velvet—accompanied by a letter cautioning her to avoid "using the color blue for appliances and napkins and things of that sort."

LEFT: Ellen Hulda Johnson and sculptor Claes Oldenburg at Hammarskjöld Plaza, New York City, 1974. Photograph by Roxanne Everett. Ellen Hulda Johnson papers, 1939-1980.

BELOW: Ellen Hulda Johnson at Oberlin College commencement, 1972. Photographer unknown. Ellen Hulda Johnson papers, 1939-1980.

RIGHT: "Rev." Royce Dendler to Ellen Hulda Johnson, ca. 1971, enclosing a "love charm." 1 page. Ellen Hulda Johnson papers, 1939-1980. TRANSCRIPTION ON PAGE 104.

...you are a person who knows Herself, both strengths & shortcomings.

Dear Ellen,

~ Enclosed is a Love Charm

[And especially extra for you — some of my
literature!]

 Through Psychometry I received that
you are a person who knows Herself, Both strengths
& short comings. I also received caution about your
using the color blue for appliances and napkins
and things of that sort. The spirits add, " you should
be kind to those lower than you." The person from
the other side w/ initials M.D. says " he is proud
of you."

 Your lucky number is " 9 "

 Ohio previously acknowledged expert palmist is the
librarian at Grafton Library (housed at the High School).
You ought to meet her definately. Incidentally,
the Grafton Public library has the best Ohio Library
on the Occult because of the above mentioned.
Dorothy L. Snecker (211 "8" St Elyria Ohio or Grafton Library)

 Rev Royce Dendler

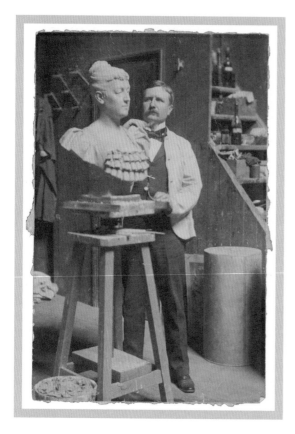

ALEXANDER DOYLE

(1857–1922)

♥

FANNIBELLE JOHNSON

(dates unknown)

Alexander Doyle was known for his civic sculpture. In 1879, he was in New Orleans working on his monument to the Washington Artillery, a military regiment founded in Louisiana in 1838. The monument, in Metairie Cemetery, honors members of the regiment who died in the Civil War and other conflicts.

Doyle's work took him away from fiancée Fannibelle in Hallowell, Maine. In this letter, he frets over their separation: "Oh! Fannibelle if you knew how my heart aches to see you, you'd not think that I stay a moment of time more than necessary." They were married the following year, on December 21, 1880. They continued to live in Maine, although his commissions for war memorials took him all over the United States.

When Doyle died in 1922, Charles Francis Meserve of the Raleigh, North Carolina, *News & Observer* wrote of Doyle's enduring love for Fannibelle: "For several years his wife had been an invalid and up to the time of his final illness his devotion to her well-being was beautiful and unfailing."

LEFT: Alexander Doyle in his studio with an unidentified bust, ca. 1894. Alexander Doyle papers, 1852–1937.

RIGHT: Alexander Doyle to his fiancée, Fannibelle Johnson, 11 May 1879. 3 pages. Alexander Doyle papers, 1852–1937. TRANSCRIPTION ON PAGE 104.

*If I could come by telegraph
I would be with you in a few minutes
but my darling, reason must as it always
should gain the day over blind desire.*

New Orleans, 5 — 11 — 1879

My darling

Your dear letter
has just been placed
in my hand by the
aforesaid clerk of the
Hotel who was gracious
enough to bring it up to
the room himself

I have just
finished casting my figure
and am over head and eyes
in plaster. So if any thing
disappoints you in this
letter don't blame me se-
verely, dear.

Please don't
grieve if I am not back
in Hallowell by Friday
night, you don't know how
I should like - like, oh!
ever so much to be and

FRANK VINCENT DUMOND

(1865–1951)

♥

HELEN XAVIER

(1872–1968)

When Frank Vincent DuMond died at 85, he had taught at the Art Students League of New York for nearly sixty years. He came to the League to study in 1884 and, after establishing himself as an illustrator, returned to teach in 1892. The following year he fell in love with one of his students, Helen Xavier. They married on March 9, 1895, in her hometown of Portland, Oregon.

In 1894, DuMond was in France with a group of students when he wrote to tell Xavier of a disastrous fire that destroyed his studio in the Vandyke Building in New York City. The fire, which started in the studio of Jules Turcas on the sixth floor, consumed the top three floors of the building and more than twenty artists' studios. "Everything I had in the world was in that studio and I am afraid to sit down and think over the different things which are probably utterly ruined," wrote DuMond. Instead of dwelling on his loss, however, he looked to the future with his bride: "…since we are going to begin together soon why its a fine thing to think of leaving all my old world behind and beginning in a new and better one." He had pulled his thumb out of joint, and to show his injury, he made a letterhead of swollen thumbprints. He ended with four *k*s in circles, presumably kisses.

LEFT: Frank and Helen DuMond, ca. 1898. Photographer unknown. Frank Vincent DuMond papers, 1866-1982.

RIGHT: Frank Vincent DuMond to Helen Xavier [August 1894]. 6 pages. Frank Vincent DuMond papers, 1866-1982. TRANSCRIPTION ON PAGE 105.

different things which are
probably utterly ruined.
Just imagine how the
dear old place must look
with the charred and
ragged remains of all my
rugs and the stuff which
covered the walls and the
sofa cushions with the
feathers half burned and
scattered about. You and
the winter clothes hanging
on the hooks or in ____
on the floor – all soaked
with water and mingled
with broken window glass
and stinking with smoke.
Then too is the chest of drawers,
my big easel, a thousand
photographs, some of Rose's
pictures and frames and

Sweetheart

Just think of the
accident which has
happened to me. I en-
close a couple of slips
cut from the Telegraph
news of the Paris edition
of the New York Herald,
which will explain it
all — So I've really
been burned out. What
shall I do when I go
back to New York City?
Everything I had in the
world was in that studio
and I am afraid to sit
down and think over the

Here's a kiss for every little red toe you have.

STYRBJÖRN ENGSTRÖM

(dates unknown)

♥

DUANE HANSON

(1925–1996)

*...I would be
a very happy man,
if you send me a card/letter
and tell me
where I can find you....*

In 1975, Styrbjörn Engström, an aspiring young artist in Stockholm, Sweden, was moved to write a letter to American sculptor Duane Hanson. Engström was planning a trip to the United States and hoped to meet his idol. Hanson, who was of Swedish descent, was known for his superrealist sculptures of ordinary people, often tinged with social commentary. He received loads of fan mail.

It is not known if Engström ever met Hanson, but he did continue in the arts as a film production designer.

LEFT: Duane Hanson in 1984 with his sculpture *Football Player*, 1981, oil on polyvinyl. Lowe Art Museum, Miami, Florida. Photographer unknown. Duane Hanson papers, 1969-1995.

BELOW AND RIGHT: Styrbjörn Engström to Duane Hanson, 10 April 1975. 2 pages. Duane Hanson papers, 1969-1995. TRANSCRIPTION ON PAGE 106.

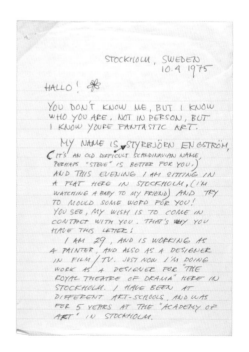

YOUR WORK HAVE MEAN A LOT FOR
ME, IN MANY WAYS!

TO THE POINT! MY QUESTION IS,
(I hope you don't think it's a insolent question)
IF IT IS POSSIBLE FOR ME TO SEE
YOU WHEN I COME TO USA FOR A
4 WEEKS HOLIDAY. MY MOTIVE FOR
MY TRIP TO USA IS TO VISIT SOME
FRIENDS, HAVE IMPRESSIONS, EXPERIENCE,
AND IF IT'S POSSIBLE, MEET YOU!
I'M PLANING TO GO TO NEW YORK,
ROUND 20.5 (20th MAY) AND GO BACK
TO SWEDEN ROUND 20.6 (20th JUNE)
I KNOW THAT YOU PERHAPS IS VERY
BUSY, BUT IF YOU HAVE TIME, I WOULD
BE A VERY HAPPY MAN, IF YOU SEND
ME A CARD/LETTER AND TELL ME
WHERE I CAN FIND YOU, (ADRESS + PHONE)

O.K. THATS ALL! I HOPE YOU WILL
HAVE A NICE TIME, AND THANK YOU FOR
READING THIS. YOUR:

STYRBJÖRN ENGSTRÖM
ÖSTERMALMSGATAN 64
11450 STOCKHOLM
SWEDEN.

(PLEASE SEND ME THE
CARD/LETTER AS SOON AS POSSIBLE)

(P.S. I HOPE MY ENGLISH ISN'T TOO BAD OS)

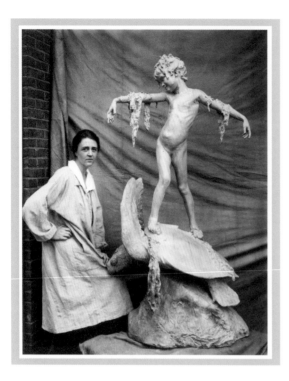

LEFT: Beatrice Fenton with her *Seaweed Fountain*, ca. 1920. Photographer unknown. Beatrice Fenton papers, 1890-1983.

BELOW: Beatrice Fenton to Marjorie Martinet, undated. 1 page. Beatrice Fenton papers, 1890-1983. TRANSCRIPTION ON PAGE 106.

RIGHT: Marjorie Martinet poem, "My love is like the sea; returning– as the tide–" dedicated "To my friend B. F.," May 1915. 1 page. Beatrice Fenton papers, 1890-1983. TRANSCRIPTION ON PAGE 107.

Sculptor Beatrice Fenton met painter Marjorie Martinet and sculptor Emily Clayton Bishop when they were fellow students at the Pennsylvania Academy of the Fine Arts in Philadelphia. The three women began a lifelong friendship. When Bishop died in 1912, Fenton and Martinet promoted Bishop's sculpture. Martinet (who changed the spelling of her surname from Martenet in June 1918) established her own art school in Baltimore, Maryland, and later taught painting at the Maryland Institute of Art. Fenton and Martinet nurtured a romance for fifty years. While Martinet's letters to Fenton are not as direct as Fenton's to Martinet, she gave free rein to her emotions in her poetry.

BEATRICE FENTON

(1887–1983)

♥

MARJORIE MARTINET

(1886–1981)

I would pour out to you
the tenderest
and the most fervent love
I know
if you were here to-night,
Beloved.

My best Beloved:— Sat. evening
6 p.m.

The lovely, fragrant hyacinths have just come — a large pot of beautiful radiant white ones! How dear of you to send them! I was just in the act of playing Shubert's Serenade when they arrived, to lull or express an indefinable longing, and thinking of you Beloved, and how you liked it.

Many thanks, dear, for your loving thought and the beautiful plant.

I would pour out to you the tenderest and the most fervent love I know—if you were here to-night, Beloved. I wish I could do more than write it, or at that I could write poetry.

You are so dear, Marjorie!
With a thousand kisses —
your Beatrice

My love is like the sea;
 returning — as the tide —

Out far out I know not whither goo my love then as the tide.
Far, far, called by the moon, mad muse —
Ebb, ebb, ocean ward a call unhuman do I harken unto
To that great vast expanse of enderor do I go —

———

But then also as the tide my longing turns landward
Ardent then my love, on, on, returning.
Sweet land! nearer, nearer, higher, higher,
Fair cliff mine kisses know; dear earth beloved beach!

———

Upon the breast then of the beach weary the waves find peace
Sweet beach of all my wandering hopes; I whisper softly.
Loving ly with embracing pleading
Gently then with kisses speaking, unto the lovely shore, your love —

———

to my friend B.F.
May 1915
Marjorie D. Trautwine

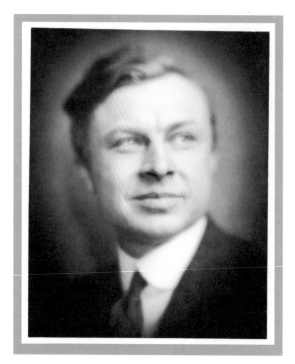

ALFRED JOSEPH FRUEH

(1880–1968)

♥

GIULIETTE FANCIULLI

(1882–1967)

Al Frueh was known for his elegant caricatures of theater personalities, which appeared in the *New Yorker* from its first issue in 1925 until 1962. On his second trip to Europe in 1912 and 1913, he wrote more than two hundred letters to his fiancée, Giuliette Fanciulli, in New York City, all illustrated and each one a charmer. This note dated November 26, 1912, is typical of his humor—two sentences followed by thirty-five postscripts. Giuliette was planning to visit him in Paris, and with each P.S. he coaxed her to come. She finally arrived in May 1913, and they were married in London the following month.

LEFT: Alfred Joseph Frueh, n.d. Photograph by Nickolas Muray. Alfred J. Frueh papers, 1904-1993.

BELOW, LEFT: Alfred Joseph Frueh, caricature of Dick Van Dyke, n.d. Alfred J. Frueh papers, 1904-1993.

BELOW AND RIGHT: Alfred Joseph Frueh to Giuliette Fanciulli, 26 November 1912. 6 pages. Alfred J. Frueh papers, 1904-1993. TRANSCRIPTIONS ON PAGES 107 AND 108.

P.S. — Send me back my heart right away

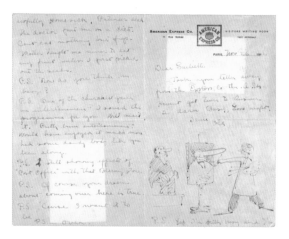

P.S. I'm going right down to the doctor and wait for you.

P.S. Let me know quick the exact date of your coming so I can begin to count the days

P.S. I don't know for sure just where I'll be in the spring but if I'm within a thousand miles of this town I'll come here if you do.

P.S. I would sooner be where you are when you're there, than lots of other places

P.S. I mean places like "Any place else", "Any other place", and "Any place in the world"

P.S. Take your pick.

P.S. No. I don't mean, and I did not say "Any old place"

P.S. I am only in Paris because I'm waiting. The Legion of Honor is going to send for me soon. They want me to wear some of their medals, I think.

P.S. Gee Girl. If you treat all your friends when they sail as well as you treated me, you must be a pretty busy girl

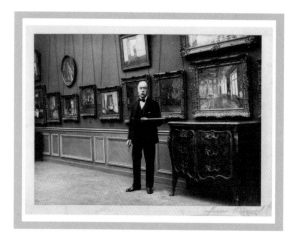

WALTER GAY

(1856–1937)

♥

MATILDA TRAVERS

(ca. 1866–1943)

When Walter Gay died, the *New York Times* described him as the "dean of American artists in Paris." In 1876, at age 20, he moved to France and remained there for the rest of his life, specializing in paintings of eighteenth-century French interiors. In 1889, he wrote to his fiancée, Matilda Travers. She was away in Nice, France, and he was desperate for a letter from her. Every day he met the mailman "with a beating heart, only to be disappointed." Gay was studying the details of French marriage law and debating whether it would be simpler to marry in London. Evidently it was. The couple married in London that same year.

LEFT: Walter Gay holding a palette standing in a gallery of paintings, n.d. Photographer unknown. Walter Gay papers, 1870-1980.

BELOW AND RIGHT: Walter Gay to Matilda Travers, 1 March 1889. 4 pages. Walter Gay papers, 1870-1980. TRANSCRIPTION ON PAGE 108.

*If you only knew
how I want you,
my darling, my darling!
You will know
when we are together
and I can prove it.*

18 Rue d'Armaillé

March 1. 89

My dear Matilda

I have waited in
vain for a letter from
you today.

Every time the Facteur
comes, I have met him
with a beating heart,
only to be disappointed.
If you only knew how
I depend upon this
letter from Nice. It is
the only respite I have,
during the live long
day, from my troubles.
I am unhappy, the whole

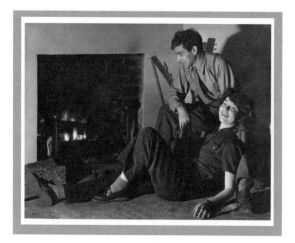

XAVIER GONZALEZ

(1898–1993)

♥

ETHEL EDWARDS

(1914–1999)

*I told them all about you
they think you are the most
georgeous girl and etc etc—
which is music to my ears,
I love to hear people talk like this
about my darling---------
But I was mean I said
you were slim as a papyrus
and an artist.*

Xavier Gonzalez had a lively and versatile career as a painter, sculptor, muralist, and graphic artist. He also taught with his uncle José Arpa in San Antonio, Texas, and at Sophie Newcomb College in New Orleans. Later he opened his own summer school in Wellfleet, Massachusetts. In 1935 he married one of his Newcomb College students, Ethel Edwards.

His personal papers include hundreds of love notes to Ethel, who was also an artist and an instructor at the Art Students League of New York.

In pen and watercolor, these quick illustrated messages, often with clues to his whereabouts, convey his enduring affection for Ethel and the humor that sustained them through fifty-seven years of marriage.

LEFT: Xavier Gonzalez and Ethel Edwards in New Orleans, ca. 1936. Photographer unknown. Xavier Gonzalez papers, 1905-1970.

BELOW: Xavier Gonzalez in his studio, ca. 1960. Photographer unknown. Xavier Gonzalez papers, 1905-1970.

RIGHT: Xavier Gonzalez to Ethel Edwards, 28 November 1955. 3 pages. Xavier Gonzalez papers, 1905-1970. TRANSCRIPTION ON PAGE 109.

PAGES 44-45: Xavier Gonzalez, illustrated notes, n.d. Xavier Gonzalez papers, 1905-1970.

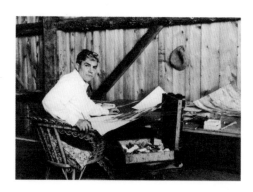

Hotel Ritz
Paseo del Prado
Madrid
Nov. 28 -1955

Sweetheart:
There are exactly 6 hours
difference. My watch says –
Flew directly from N-Y to
Madrid couldn't land in
Lisbon because of low
Clouds – Must be about 2
pm in Wellfleet now and
my heart is lonesome for you

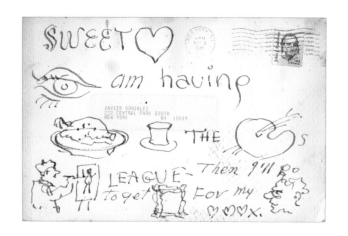

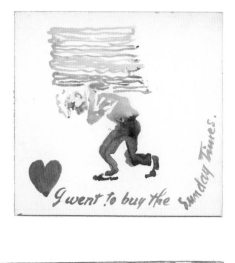

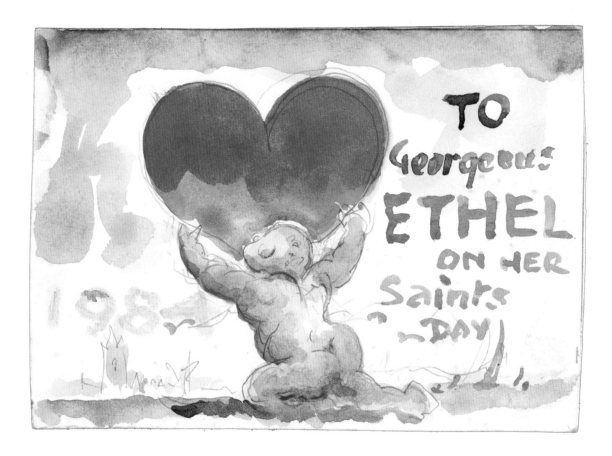

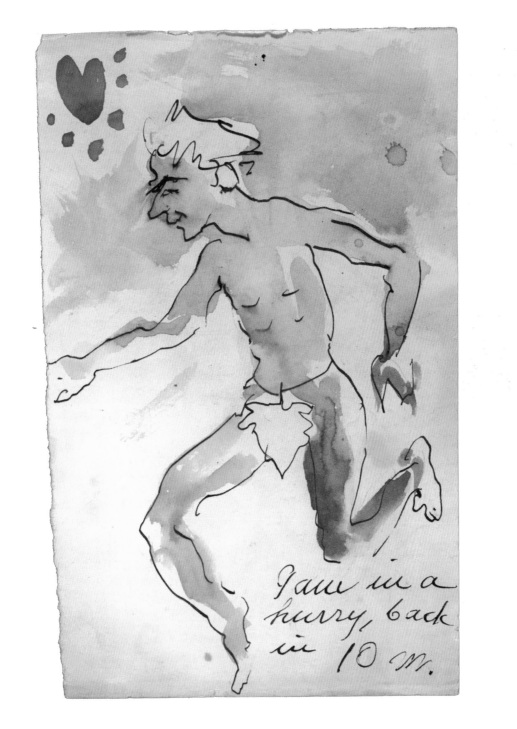

I am in a hurry, back in 10 m.

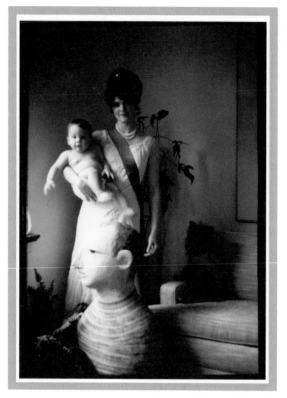

Friends of artists Cynthia Hart and Angelo Ippolito refer to their 1958 marriage ceremony—held in a shack on the beach in Provincetown, Massachusetts—as the "first hippie wedding." Around that time, Cynthia wrote a short illustrated story of their fairy-tale love. A draftsperson and sculptor, she drew a charming sketch that captures the free-spirited life of artists in love. Her husband, Angelo Ippolito, was an abstract expressionist painter, a founder of the Tanager Gallery (an artist-run space on East Tenth Street in New York City), and a well-loved teacher at Yale, the University of California, Michigan State, Cooper Union, and elsewhere.

LEFT: Cynthia Hart holding her son Jon Ippolito, 1958. Photographer unknown. The sculpture in the foreground is a portrait of Angelo Ippolito by William King (1955). Jon Ippolito is an artist, writer, and curator.

RIGHT: Cynthia Hart, ca. 1958. Story, 1 page. Harold Paris papers, 1946–1982. TRANSCRIPTION ON PAGE 109.

CYNTHIA HART IPPOLITO

(b. 1935)

♥

ANGELO IPPOLITO

(1922–2001)

...and they lived happily
ever after in his studio.

ONCE UPON A TIME THERE LIVED AN ARTIST; A MAN
WHO PAINTED BEAUTIFUL PICTURES OF LANDSCAPE. HE WAS
VERY HANDSOME, WITH BLUE-BLACK AND STRAIGHT SHINY
HAIR. HIS NOSE WAS TERRIBLY LONG AND ELEGANT,
LIKE THIS.

ONE DAY HE HAPPENED TO MEET A LOVELY
YOUNG PRINCESS AND FELL IN LOVE WITH HER
AND THEY LIVED HAPPILY EVER AFTER TOGETHER IN
HIS STUDIO.

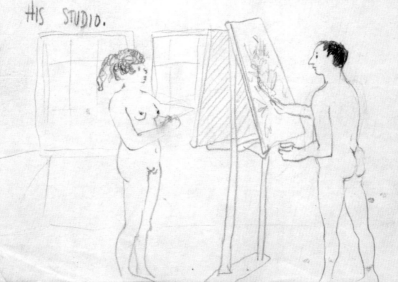

Sculptor Grace Mott Johnson and painter Andrew Dasburg had a tortured love affair. They married in London in 1909, but not without considerable soul-searching, as Johnson was a modern woman and a free spirit. At 22, she received a small inheritance from her mother and set out for New York City, where she enrolled in the Art Students League. She and Dasburg met in the summer of 1907 at the League's summer school in Woodstock, New York. Johnson specialized in animal figures. She may have been sculpting a calf when Dasburg sent her a valentine on League stationery, addressed to "Miss Grace Mott Johnson The Calf." His illustration of two heifers—one saying "Yes!" and the other "No!"—hints at her ambivalence toward him.

In 1908 she wrote from Columbus, Ohio, where she was on the Hartman stock farm studying horses and cattle. "There are so many ways in which it seems to me I should not satisfy you that I wish you would reflect upon them and tell me whether, when weighed in cold blood they should not make you reconsider your choice…. On my side I will try to be quite frank and tell you of some of the ways in which you may not fully satisfy me."

They finally gave in to their passions. Three months later she wrote, simply, "All day I wanted to tell you that I love you." Four years after their wedding, both artists were included in the landmark 1913 Armory Show, the first large-scale exhibition of modern art in America. They separated in 1917 and divorced in 1922, but remained close friends through correspondence.

GRACE MOTT JOHNSON
(1882–1967)

♥

ANDREW DASBURG
(1887–1979)

LEFT: Grace Mott Johnson, ca. 1900. Photographer unknown. Andrew Dasburg and Grace Mott Johnson papers, 1854-1979.

RIGHT: Grace Mott Johnson posing nude, ca. 1911. Photographer unknown. Andrew Dasburg and Grace Mott Johnson papers, 1854-1979.

PAGE 50: Andrew Dasburg to Grace Mott Johnson, ca. 1907. 1 page. Andrew Dasburg and Grace Mott Johnson papers, 1854-1979. TRANSCRIPTION ON PAGE 109.

PAGE 51: Grace Mott Johnson to Andrew Dasburg, 2 August 1908. 12 pages. Andrew Dasburg and Grace Mott Johnson papers, 1854-1979. TRANSCRIPTION ON PAGE 110.

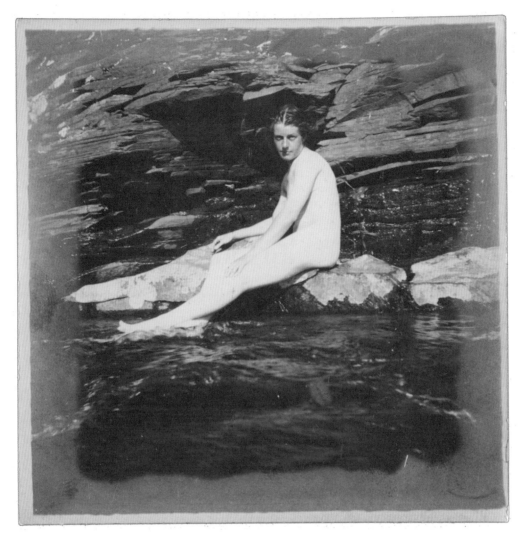

*I hope I can live up to my conviction that each
is responsible to himself alone and has no claims upon the other.
It seems to me the only solid basis of respect and peace of mind
in whatever relation of life, between free and equal individuals.*

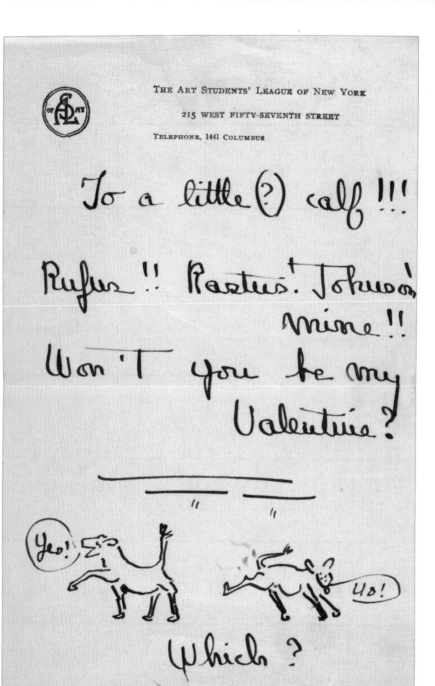

THE ART STUDENTS' LEAGUE OF NEW YORK

215 WEST FIFTY-SEVENTH STREET

TELEPHONE, 1441 COLUMBUS.

P.S. Remember
me to your fam-
ily.

My dear Andrew;

Your letter
of the 30th utt. which Mr. Hark
brought me soon after I mailed
my short note to you, was
very interesting, if written
under difficulties; and
set me thinking of many
things. accumulated
 A great deal has ~~accumid~~
in my mind ~~recently~~ that I
should like to speak with you
about in the hope that ~~there~~
might be a fuller understand-
ing between us. My surround-
ings are more conducive to

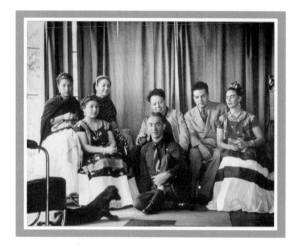

FRIDA KAHLO

(1907–1954)

♥

NICKOLAS MURAY

(1892–1965)

My lover, my sweetest,
mi Nick—mi vida—mi niño,
te adoro….
All my tenderness
and all my caresses
to your body,
from your head to your feet.
Every inch of it
I kiss from the distance.

In 1939, Frida Kahlo was married to the preeminent Mexican muralist Diego Rivera. She was just beginning to gain international fame as a surrealist painter. She had fallen in love with dashing Hungarian-American Nickolas Muray, a popular and gifted photographer whose portraits of celebrities appeared in *Vanity Fair*, *Vogue*, *Time*, and other magazines. While their intermittent affair may have begun as early as 1931, Kahlo's letters to Muray, written while she was in Paris in February 1939, reveal the intensity of her feelings for him—as well as her impetuous and uninhibited nature.

Surrealist André Breton had invited Kahlo to Paris to exhibit her paintings, but when she arrived she learned that her paintings were held up in customs and that Breton had done nothing to organize a show. To make matters worse, she took ill and was hospitalized for a kidney ailment. "They are all so damned 'intellectual' and rotten that I can't stand them anymore," she wrote. "It is really too much for my character. I'd rather sit on the floor in the market of Toluca and sell tortillas, than have anything to do with those 'artistic' bitches of Paris." Marcel Duchamp came to her rescue. He retrieved her paintings and arranged for a group exhibition at the Pierre Colle Gallery that opened on March 10, 1939. While Duchamp and his companion Mary Reynolds comforted Kahlo, she longed for Muray. "I adore you so much," she wrote, "I need you so, that my heart hurts." Despite Frida's passionate outpourings, Muray married someone else in June 1939. Kahlo and Rivera divorced on November 6, 1939, and remarried on December 8, 1940.

LEFT (FROM LEFT TO RIGHT): Alfa Ríos Henestrosa and Beta Ríos Pineda (Rivera's models), Rosa Covarrubias, Diego Rivera, Nickolas Muray, Miguel Covarrubias, and Frida Kahlo in one of the twin houses that belonged to Rivera and Kahlo in San Ángel, Mexico, 1938. Photograph by Nickolas Muray (who holds a timer in the photo). Nickolas Muray papers, 1911–1978.

RIGHT: Frida Kahlo to Nickolas Muray, 27 February 1939. 8 pages. Nickolas Muray papers, 1911–1978. TRANSCRIPTION ON PAGE 112.

at the sculpture near the ~~kissing~~ fire place.
I see clearly, the spring jumping on the air,
and I can hear your laugh - just like a
child's laugh, when you got it right. Oh
my darling Nick I adore you so much. I
need you so, that my heart hurts.

I imagine Bla~~n~~che will be here the first
week of March. I will be so happy to see
her because she is a real person, sweet
and sincere, and she is to me like a part
of yourself.

~~How are~~ Aria and Lea? Please give my love
to them. Also give my love to the Kid Ruzzie
tell him that he is a ~~swel~~ swell guy.

My darling, do you need anything from Paris?
please tell me, I will be so happy to get you any
thing you may need.

If Eugenia phones you, please tell her that I
lost her adress and that is why I didnt write.
How is that wench?
If you see Rosemary give her lots of Kisses. She
is O.K. To Mary Sklar lots of love. I miss
her very much.

To you, my loveliest Nick, all my heart, blood
and all my being. I adore you. Frida.

The photographs you sent finally arrived.

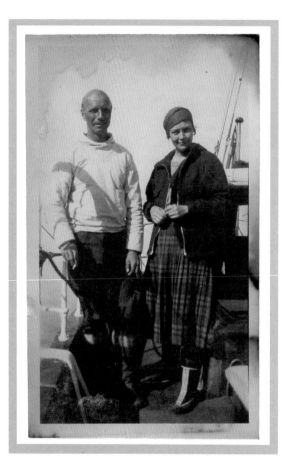

Rockwell Kent—a painter, printmaker, illustrator, writer, lecturer, explorer, political activist, and dairy farmer—married three times. He met his second wife, Frances, in 1926. He pursued the newly divorced, blue-eyed blonde eighteen years his junior with torrid love letters. Just before they married in April 1926, Kent, who was keenly attuned to typography, designed several monograms using her new initials, FLK. In the space of a few months, and with a flourish of his pen, he had redesigned her as his wife.

LEFT: Rockwell and Frances Kent on the boat to Greenland, ca. 1930. Photographer unknown. Rockwell Kent papers, ca. 1840–1993.

RIGHT: Rockwell Kent to Frances Lee, ca. 1926. 2 pages. Rockwell Kent papers, ca. 1840–1993.

PAGE 56: Rockwell Kent with his mural for the General Electric Building at the New York World's Fair, 1939. Photographer unknown. Rockwell Kent papers, ca. 1840–1993.

PAGE 57: Rockwell Kent to Frances Lee [March 1926]. 1 page. Rockwell Kent papers, ca. 1840–1993. TRANSCRIPTION ON PAGE 114.

ROCKWELL KENT

(1882–1971)

♥

FRANCES LEE

(1900–1986)

*...to be near you,
to see you, hear you,
touch you, is now
the only happiness,
the only life, I know.*

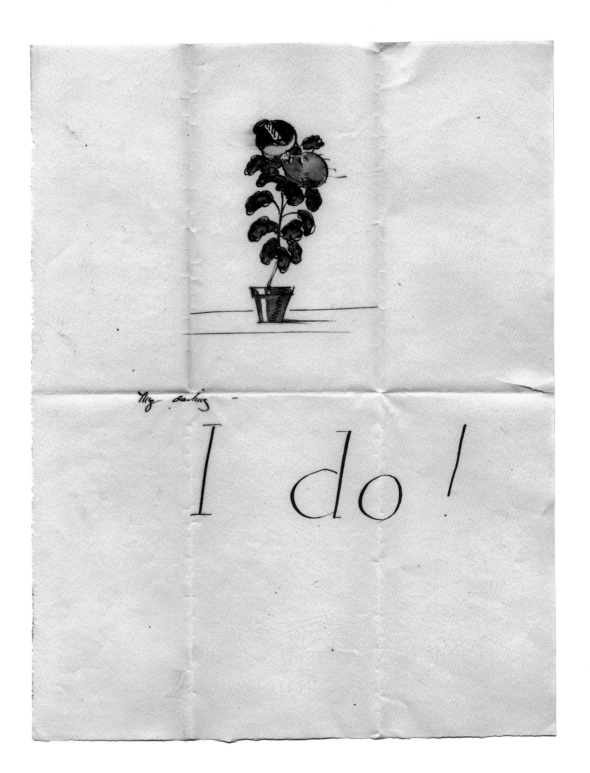

My darling —

I do!

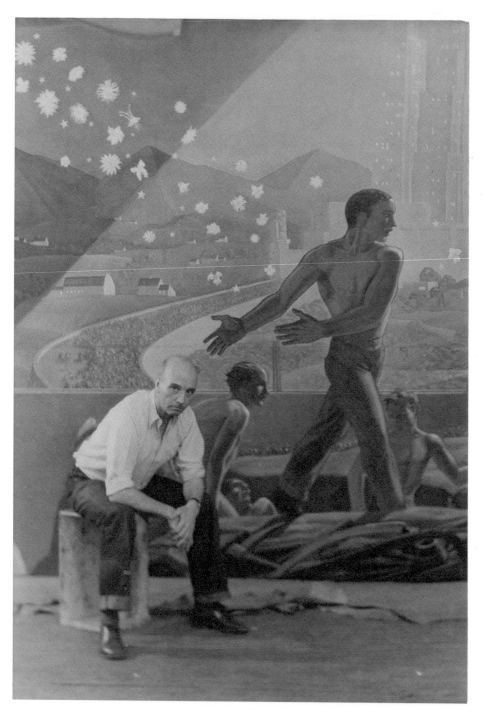

Frances! I am so lonely I can hardly bear it. As one needs happiness so have I needed to love; that is the deepest need of the human spirit. And as I love you utterly, so have you now become the whole world of my spirit. It is beside and beyond anything that you can ever do for me; it lies in what you are, dear love — to me so infinitely lonely that to be near you, to see you, hear you, touch you, is now the only happiness, the only life, I know. How long these hours are alone!

Yet is good for me to know the measure of my love and need, that I may at last be brought to so govern myself as never to lose the love and trust that you have given me. Dear Frances, let us make and keep our love more beautiful than any love has ever been before.

Forever, dearest one.

thy

Rockwell.

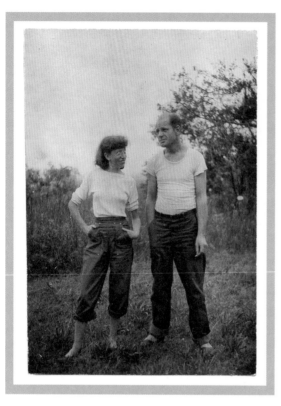

LEE KRASNER

(1908–1984)

♥

JACKSON POLLOCK

(1912–1956)

Jackson Pollock transformed American art with his dripped and poured paintings. His wife, Lee Krasner, was a significant abstract painter in her own right. They met at a party in New York City in 1936. Krasner was at first unimpressed. Five years later she visited his studio and was stunned by what she saw. They married in October 1945.

In the summer of 1956, with their marriage on the rocks, Krasner left for Europe. From Paris she wrote to him, "—kiss Gyp & Ahab [their dogs] for me—It would be wonderful to get a note from you…. The painting hear is unbelievably bad (How are you Jackson?)." Three weeks later, Pollock died in a car crash. Krasner learned of his death while still in Paris.

LEFT: Lee Krasner and Jackson Pollock in East Hampton, ca. 1946. Photograph by Ronald Stein. Jackson Pollock and Lee Krasner papers, ca. 1905-1984.

BELOW: Jackson Pollock and Lee Krasner in Pollock's East Hampton studio, ca. 1950. Photograph by Rudy Burckhardt. Jackson Pollock and Lee Krasner papers, ca. 1905-1984.

RIGHT: Lee Krasner to Jackson Pollock [21 July 1956]. 1 page. Jackson Pollock and Lee Krasner papers, ca. 1905-1984. TRANSCRIPTION ON PAGE 114.

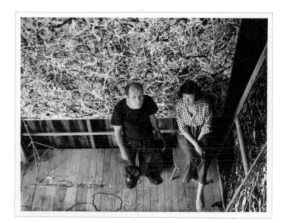

Dear Jackson — Sat —

I'm staying at the Hôtel Quai Voltaire, Quai Voltaire
Paris, until Sat the 28 then going to the South of
France to visit with the Gimpel's, & I hope to get
to Venice about the ~~end~~ early part of August — It
all seems like a dream — The Jenkins, Paul & Esther
were very kind, in fact I don't think I'd have
had a chance without them — Thursday nite
ended up in a Latin quarter dive, with Betty
Parsons, David who works at Sindney's, Helen Franken-
thaler, The Jenkins, Sidney Giest & I don't remember
who else, all dancing like mad — Went to the flea
market with John Graham yesterday — saw all the
left-bank galleries, met Druin and several other
dealers (Tapie, Stadler etc). am going to do the
right bank galleries next week — & entered the
Louvre which is just ~~an~~ across the Seine outside
my balcony which opens on it — About the "Louvre"
I can ~~say anything~~ — It is over whelming — ~~abs~~
beyond belief — I miss you & wish you were ~~sha~~
~~sharing~~ this with me — The roses were the most beautiful
deep red — Kiss Gyp & Ahab for me — It would be
wonderful to get a note from you — Love Lee —
The painting here is unbelievably bad (How are you
 Jackson?)

I miss you & wish you were sharing this with me.

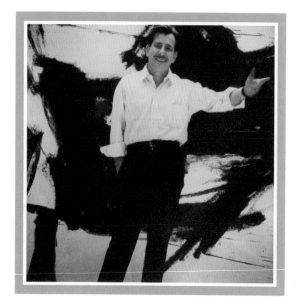

In 1959, sultry screen star Hedy Lamarr sent a fan letter to abstract expressionist painter Franz Kline. Lamarr, the sensuous, dark-haired beauty who played the first nude scene in cinematic history in the 1933 Czech film *Ecstasy*, describes a visceral reaction to Kline's painting.

LEFT: Franz Kline, ca. 1960. Bert Stern photographer. Miscellaneous photograph collection.

RIGHT: Hedy Lamarr to Franz Kline, 19 July 1959. 1 page. Elisabeth Zogbaum papers regarding Franz Kline, 1928-1965.

HEDY LAMARR

(1913–2000)

♥

FRANZ KLINE

(1910–1962)

When I first saw
one of your paintings…
I had to sit down
because it did something
to me.

614 No. Beverly Drive
Beverly Hills, Calif.

19 July 1959

Dear Mr. Franz Kline:

When I first saw one of your paintings, done
about 1950, I had to sit down because it did
something to me.

Since then I've found out that you're one of
the leading forces in contemporary American
painting. This by itself wouldn't at all in-
fluence me to get anything of yours unless I
really otherwise respected your guts.

But, there is something I'm anxious to find
out: Are you by any chance of Austrian des-
cent - since I am.

Please do let me know.

Fondly,

Hedy Lamarr

P.S.

Incidentally I do have a small 1953 picture
of yours done on a telephone book page which
I cherish very much.

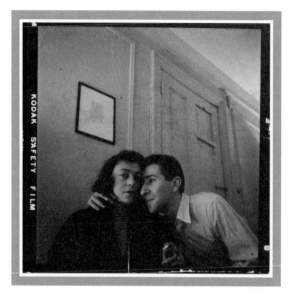

JOAN MITCHELL

(1925–1992)

♥

MICHAEL GOLDBERG

(b. 1924)

In early 1951, painter Joan Mitchell moved out of the apartment she shared with her husband, Barney Rosset, and into a bare studio at 51 West Tenth Street in New York City. She had fallen in love with fellow abstract expressionist Michael Goldberg. "I keep thinking we could live here together but I mustn't think at all," she wrote. Goldberg was at the Rockland State Hospital in Orangeburg, New York, where he was spending six months in lieu of doing prison time for having written fraudulent checks drawn from the account of Mitchell's husband.

At the time, Mitchell's career was just beginning to take off. She was considering her options for galleries and exhibitions, but found it difficult to move forward without Goldberg. Though their affair did not last, she ended her letter with a dream of their future together: "Save your drawing ideas & someday we'll live [in] a room with canvas & you'll have an enormous brush & lots of black & white & cad. red deep & you'll paint them all at once and I'll have my arms around you."

TOP: Joan Mitchell and Michael Goldberg, ca. 1950. Photographer unknown. Michael Goldberg papers, 1942–1981.

BOTTOM: Joan Mitchell with her painting *Untitled* (1951) in her parents' apartment in Chicago, ca. 1953. Photographer unknown. Michael Goldberg papers, 1942–1981. All works by Joan Mitchell © The Estate of Joan Mitchell.

RIGHT: Joan Mitchell to Michael Goldberg [1951]. 4 pages. Michael Goldberg papers, 1942–1981. All works by Joan Mitchell © The Estate of Joan Mitchell. TRANSCRIPTION ON PAGE 114.

God you mean a lot to me—it's never been
like this before in my life…. I'm using
the paint off your palette—I feel so close to you.

the way who's always looking out the window.
I'm sick of looking at her. I put all four
lights over the curtains and make coffee
often. It's so quiet and stays light so long
& what are you thinking - Oh Micheal I wish
I could help you - Parsons came - very
enthusiastic - said she was full but would
talk to Dorothy Miller etc. She was nice.
I dislike the new Gallery anyway - what do
you think of all this - should I have a
show there - without you it's impossible -
Quiero morir - but I won't - Do you
realize Micheal that I'll see you again -
a light in the darkness - and it can't
be so very much longer - but I will
see you & talk to you - what a beautiful
thing. Micheal I'll write you more
often - it's just a little easier to do
it now - how do you spell what the
pig's said? - I will sleep now -
maybe - it used to be so easy —
and the cat is filled with you - save
your drawing ideas & someday will line a
room with canvas & you'll have an enormous
brush & lots of black & white & cad. red

in any garden. the only thing I look forward to
is writing you & then I can't write anything.
I wrote you a letter yesterday to WES instead of 7
- I hope you get it - I'm sorry - I don't know what
happened. Micheal make me strong - make you strong -
your Mother & father are seeing (about tomorrow -
at 1:45- I'll meet them afterwards - do you
remember running up Madison - we still are running
to meet each other darling - and it can't be
forever - it would be so wonderful to see you.
I can't leave you money for a little while - a
week or so - then I will. I'm thinking the bees
you left on the windowsill - & I'm kissing you - this
I do all the time. How long will it be.?? I
can understand you not being able to draw -
it sounds impossible - I sometimes wonder
how in hell you painted three weeks ago -
it's over that now - I counted weeks last
fall and we were laughing. I hate tuesdays
now and the weeks start & end with it -
I got in the park this morning & you were
with me and we talked about things that
we had never mentioned & much we had and
I held your hand - could we make it over again
in a different way? There's a woman across

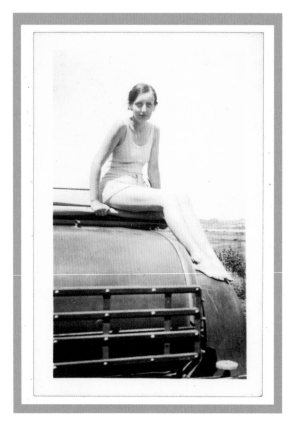

When Elizabeth Orr asked her husband, painter Elliot Orr, for his opinion on various matters of aesthetics, he replied to her by letter from their Cape Cod home in Waquoit, Massachusetts, where he painted landscapes and pursued his hobbies—beekeeping and gardening. In his answer, Elliot stressed the emotional content of art: "To me the Artist does something quite simple he sings songs. Some songs are sweet like the bird high up in the sky. Some songs are sad like the death of a child. While others are terrifying like the shriek of a hurricane." Orr seems to bundle up his whole being in this letter, from philosophy to mystical yearnings in the face of nature to reports on the rain and letters from the bank.

LEFT: Elizabeth Orr during her honeymoon, sitting on a car, 1933. Photographer unknown. Elliot Orr papers, 1910-1984.

BELOW: Elliot Orr on his honeymoon at the beach, 1933. Photographer unknown. Elliot Orr papers, 1910-1984.

RIGHT: Elliot and Elizabeth Orr's honeymoon cottage, 1933. Photographer unknown. Elliot Orr papers, 1910-1984.

PAGE 66: Elliot Orr in his Waquoit studio, ca. 1940. Photograph by L. B. Bridaham. Elliot Orr papers, 1910-1984.

PAGE 67: Elliot Orr to Elizabeth Orr, ca. 1936. 3 pages. Elliot Orr papers, 1910-1984. TRANSCRIPTION ON PAGE 115.

ELLIOT ORR

(1904–1997)

♥

ELIZABETH ORR

(1908–2002)

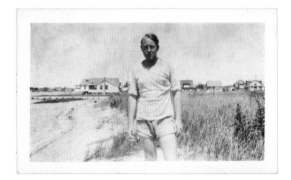

The artist loves the storm, but he loves the star lit sky too.
To love is to understand a little better.

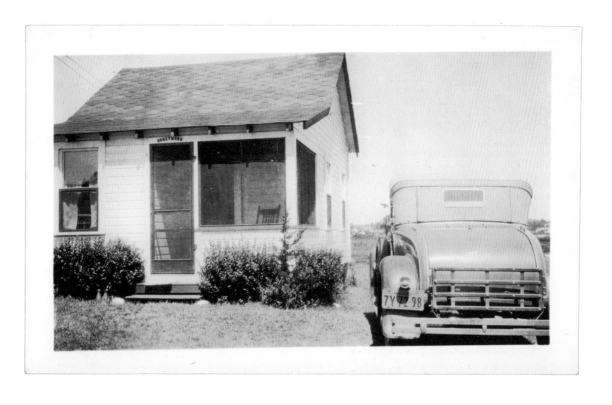

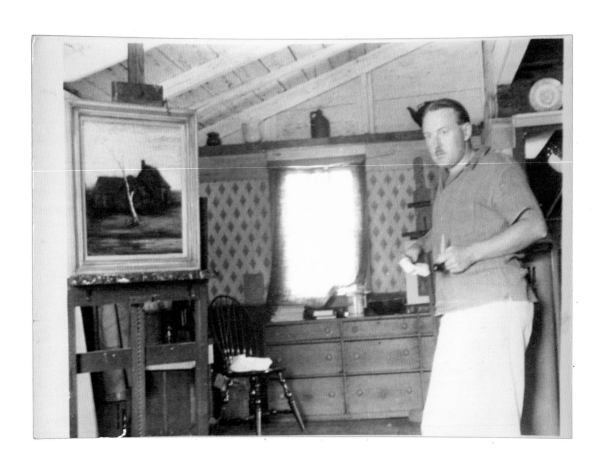

P.S. Your information concerning marshall
much appreciated. Will await
all further news. Will look
for a camp as you
suggest.
E.

Monday
Apres-midi.

Dearest Piepet:

Your noble book of Sunday arrived
on a freight car to this remote and
extreemly wet Waquait. Now after bringing
it down in the rumble seat and opening
it up I wish to report its contents satisfactory
pleasant and entertaining. I do however
reserve any praise or final comment on the contents
of lower page 7 and 8 of said book. Namely
that part which goes into some sort of
esthectics? (Damn it why did you take the dictionary)
To be more specific you ask my advice in
certain matters of an artists point of view Etc.
I am not sure that you make yourself clear
however if I interpret your statements at
all and am foolish enough to answere questions
on esthectics (even when I'm not sure what is asked)
then count me for the fool that I am about to be.

" An artist might well feel that death was
the end of Beauty for him, that is, the beauty
of the earth and of life. But I can hardly imagine any one
believing that he alone was the perpetrators of Beauty and
he alone could make that fair goddess smile.

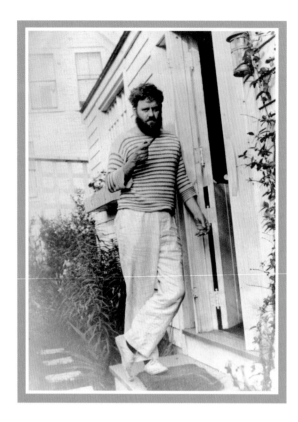

LEFT: Waldo Peirce in Provincetown, Massachusetts, ca. 1930. Photographer unknown. Waldo Peirce papers, 1903–1970.

Painter Waldo Peirce was a larger-than-life character—a tall, bearded, big-bodied man whose ebullient watercolors conveyed his sense of fun and adventure. In this silly poem (opposite page) to Sally Davis, who was serving as a captain in the Women's Army Auxiliary Corps (WAAC) in Ruston, Louisiana, Peirce playfully declares his fondness for women's breasts. The adult content of this communiqué stood in quite a contrast to the children's books he was illustrating at the time.

LEFT: Waldo Peirce in Provincetown, Massachusetts, ca. 1930. Photographer unknown. Waldo Peirce papers, 1903-1970.

BELOW: Waldo Peirce poem to Sally Davis [1943]. 2 pages, illustrated. Waldo Peirce letters, 1943. TRANSCRIPTION ON PAGE 116.

RIGHT: Waldo Peirce poem to Sally Davis [1943]. 1 page, illustrated. Waldo Peirce letters, 1943. TRANSCRIPTION ON PAGE 118.

WALDO PEIRCE

(1884–1970)

♥

SALLY DAVIS

(dates unknown)

With a fistful of cold water
She roused the sleeping Venus
"Wot about some artificial
Resperaysh between us?"

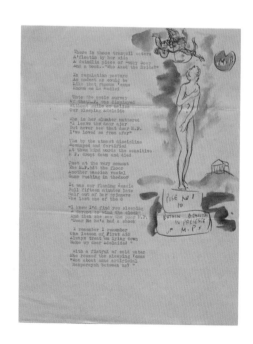

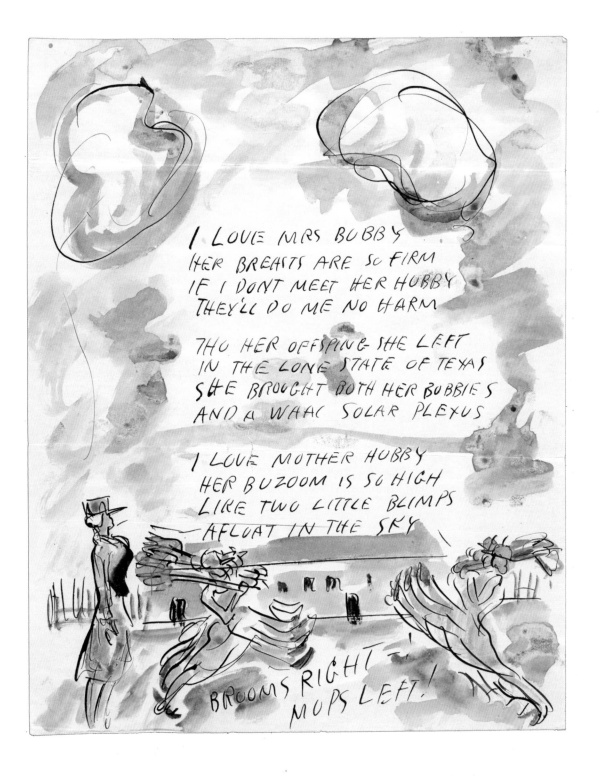

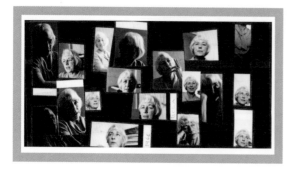

GIO PONTI

(1891–1979)

♥

ESTHER McCOY

(1904–1989)

Italian architect and designer Gio Ponti and architectural historian Esther McCoy bonded in their passion for modern design. McCoy, who began writing in earnest about architecture in 1950, as a contributor to the *Los Angeles Times*, wrote scores of articles and several significant books, most notably about modernist architecture in California. Ponti, the founding editor of *Domus* magazine, was at the forefront of the post–World War II renaissance in Italian design. His concept of total design extended to his personal letters, which were often illustrated in light, elegant lines. In this letter to McCoy, he laments his first Christmas alone after the death of his beloved wife, Giulia.

TOP: Photo montage of Esther McCoy at UCLA, 1966. Photographer unknown. Esther McCoy papers, 1896–1989.

LEFT: Gio Ponti to Esther McCoy, n.d. 1 page, illustrated. Esther McCoy papers, 1896–1989. TRANSCRIPTION ON PAGE 118.

RIGHT: Gio Ponti to Esther McCoy [December 1975]. 1 page, illustrated. Esther McCoy papers, 1896–1989. TRANSCRIPTION ON PAGE 118.

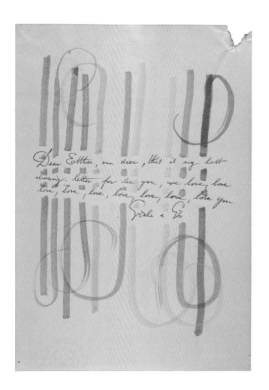

To beloved Esther with affectionate thoughts on this Christmas that for me will be the first without Giulia, alas! — Gio

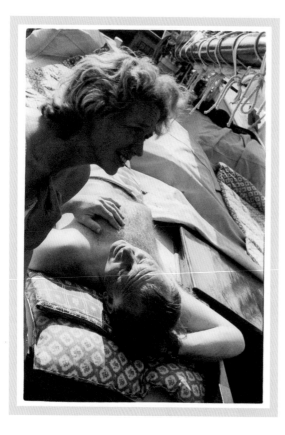

EERO SAARINEN
(1910–1961)

♥

ALINE BERNSTEIN SAARINEN
(1914–1972)

Finnish-born architect Eero Saarinen, the designer of such structural icons as the TWA terminal at Kennedy International Airport in New York City and the Gateway Arch in St. Louis, met his second wife, Aline Bernstein, on January 28, 1953. Aline, then an art editor and critic at the *New York Times* and a correspondent for NBC, was writing an article on Saarinen's new General Motors Technical Center in Warren, Michigan—a sleek corporate campus of steel, aluminum, and glass. They fell in love instantly. As Aline recalled, they stood before each other the day after their first meeting, "feeling strange and awed and breathless." In December 1953, Eero divorced sculptor Lily Swann Saarinen; he married Aline on February 8,1954. In Aline he found a soul mate, a partner, and a passionate advocate of his work.

In a letter Eero wrote to Aline in April 1953, he found a way to connect his new love for her with architecture: "The thing I liked most about the monument was that it was a beautiful result of you & I being close together—the funny thing about it is that it proves your point in your article soo much—that I translate everything into architecture."

LEFT: Aline and Eero Saarinen boating, ca. 1955. Photographer unknown. Aline and Eero Saarinen papers, 1857–1972.

PAGES 73-75: Eero Saarinen to Aline Bernstein [10-11 April 1953]. 10 pages, illustrated. Aline and Eero Saarinen papers, 1857–1972. TRANSCRIPTION ON PAGE 118.

...I love you very very much—I don't know exactly how I have come to love you so much...

ALINE

THIS WILL NOT BE WRITTEN WITH SCALPEL LIKE OBJECTIVITY IT
IS JUST GOING TO BE SMALL TALK ———— AND THAN THE
PHONE RANG AND I HEARD YOUR VERY NICE VOICE AND ALSO
ALL THE VERY NICE THINGS YOU SAID ——— OF WICH THE VERY
NICEST WAS "I LOVE YOU SO MUCH DARLING"———— WHILE
I WAS DRAWING YOUR LETTER ON THE PLANE I HAD A FELLOW
NEXT TO ME OF THE TYPE THAT JUST GETS ON PLANES TO STRIKE
UP CONVERSATIONS — HE WANTED TO KNOW WHAT I WAS DOING
BECAUSE HE WAS CURIOUS WHICH APPARENTLY WAS SUFFICIENT EXCUSE
IN HIS MIND ᵀᴼ ᴬˢᴷᵉ — I TOLD HIM IT WAS A DREAM ——— AND
CONTINUED — THE THING I LIKED MOST ABOUT THE MONUMENT
WAS THAT IT WAS A BEAUTIFUL RESULT OF YOU & I BEING CLOSE
TOGETHER——— THE FUNNY THING ABOUT IT IS THAT IT PROVES
YOUR POINT IN YOUR ARTICLE SOO MUCH — THAT I TRANSLATE EVERYTHING
INTO ARCHITECTURE———— YOU COULD NOW SAY "HE EVEN SEES HIS
CLOSEST FRIENDS AS STONE AND CONCRETE".——— OR " HE LOOKS AT
THIS REPORTER AND"——— AND SO ON ——
NOW — JUST TALKE ABOUT THINGS IN THE OFFICE THE DRAKE "BIBLE SCHOOL"
IT IS A TINY LITTLE CLASS ROOM BUILDING WITH A TINY CHAPEL — NEAR
IT IS TO BE A BIGGER CHAPEL — I THINK IT IS GOING TO BE O.K.
NOW. — IT IS LOCATED NEXT TO THE SCIENCE AND PHARMACY BUILDING
WE DID AND NOT FAR FROM DORMITORIES NOW UNDER CONSTRUCTION
— THE WHOLE THING REALLY BECOMES A CAMPUS & WHEN THESE
ARE BUILT DRAKE WILL REALLY HAVE QUITE A GOOD GROUP OF NEW
BUILDINGS. — IF PLANS ARE ACCEPTED (WEDSDAY) THAN IT WILL
LOOK LIKE THIS.

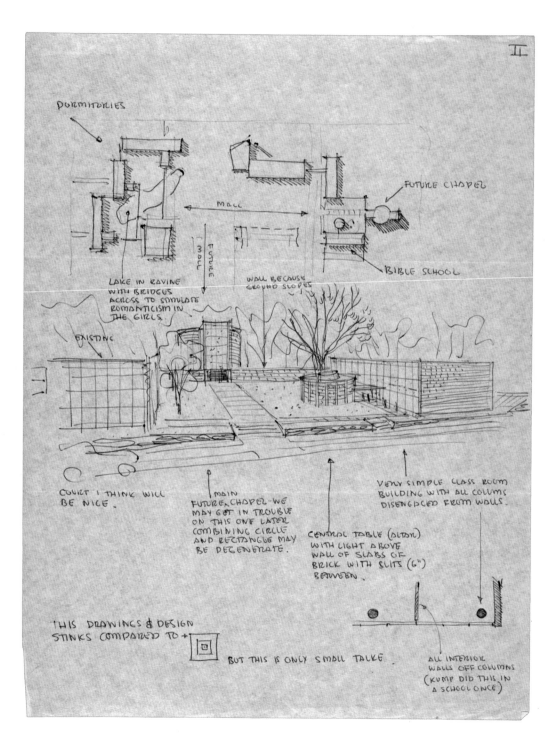

DORMITORIES

MALL

FUTURE MALL

FUTURE CHAPEL

BIBLE SCHOOL

LAKE IN RAVINE WITH BRIDGES ACROSS TO STIMULATE ROMANTICISM IN THE GIRLS.

WALL BECAUSE GROUND SLOPES

EXISTING

COURT I THINK WILL BE NICE.

MAIN FUTURE CHAPEL—WE MAY GET IN TROUBLE ON THIS ONE LATER COMBINING CIRCLE AND RECTANGLE MAY BE DEGENERATE.

CENTRAL TABLE (ALTAR) WITH LIGHT ABOVE WALL OF SLABS OF BRICK WITH SLITS (6") BETWEEN.

VERY SIMPLE CLASS ROOM BUILDING WITH ALL COLUMNS DISENGAGED FROM WALLS.

THIS DRAWINGS & DESIGN STINKS COMPARED TO →

BUT THIS IS ONLY SMALL TALK.

ALL INTERIOR WALLS OFF COLUMNS (KUMP DID THIS IN A SCHOOL ONCE)

NEXT — A SITE PLAN WE ARE DOING FOR U. OF M. — IT IS A TRIANGULAR PIECE OF GROUND AND EVERYTHING CONSPIRES TO MAKING TRIANGULAR LOTS POSSIBLE — JAY BARR INVENTED THIS ONE AND I LIKE IT VERY WELL

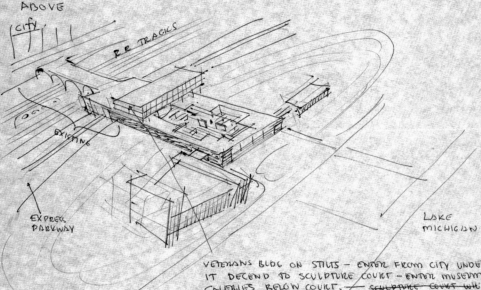

— I CANT REMEMBER HOW IT GOES BUT I THINK IT WILL BE FUN

NEXT PROBLEM — MILWAKEE CULTURAL CENTER — I HAVE BEEN SCARED TO LOOK AT IT FOR THE LAST WEEK BECAUSE MY MIND HAS BEEN SO FILLED UP BUT TO-MORROW AT 2 P.M. I AM GOING INTO IT — I THINK OUR PARTI NOW IS GOOD — I DONT THINK YOU SAW IT. — IT CONSISTS OF A VETERANS BUILDING + ART MUSEUM + THEATER FOR 3000 — THE SITE IS MAGNIFICENT BUT HAS PECULIAR PROBLEMS TOO LONG TO EXPLAIN. — YET — IF ART MUSEUM GOES AHEAD IT WILL BE VERY PECULIAR — VATICAN IS ENTERD FROM BELOW — THIS ONE WILL BE ENTERD FROM ABOVE

CITY

R R TRACKS

EXISTING

EXPRESS PARKWAY

LAKE MICHIGAN

VETERANS BLDG ON STILTS — ENTER FROM CITY UNDER IT DECEND TO SCULPTURE COURT — ENTER MUSEUM GALERIES BELOW COURT. — SCULPTURE COURT WILL MUSEUM COURT WILL BE MINGLING AREA FOR ALL ACTIVITES — VET BUILDING TO GO AHEAD ONLY UNTIL THEY COLLECT MORE MONEY.

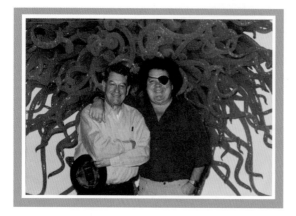

ITALO SCANGA

(1932–2001)

♥

DALE CHIHULY

(b. 1941)

Sculptor Italo Scanga and Dale Chihuly, internationally known for his work in glass, were as close as brothers. In this letter to Chihuly, Scanga describes his situation on September 20, 1941, the day that Dale was born. Scanga was then 9 years old, and struggling to survive in Lago, Italy, during World War II, with no inkling of his future best friend's birth. The two men first met in 1967, when Scanga was lecturing at the Rhode Island School of Design where Chihuly was a graduate student. They became lifelong friends and collaborators.

LEFT: Italo Scanga and Dale Chihuly, 1998, in front of Chihuly's works. Photograph by Jim Arkatov. Italo Scanga papers, ca. 1940-2001.

RIGHT: Italo Scanga to Dale Chihuly, 19 September 1997. 1 page. Italo Scanga papers, ca. 1940-2001. TRANSCRIPTION ON PAGE 122.

What a success my brother has become as an artist and human…and a brother to me.

sept 19, 1997

Brother Dale.

in Sept 20, 1941
I was 9 and ~~6~~ 4 months old. it was
during the war, and hunger was ~~so~~ running
~~rampid~~ rampid, but even then 1941
wasn't bad, like Sept 20, 1944, that was
the worst but look ~~was~~ what happen
to us. What a success my brother has
become as an artist and human. –
and what a good son to Viola ~~and~~
a brother to me. I know you don't like
birthday – I think they are silly, but some
people take them serious, Best Regards
and much Love

Brother

Italo

everyone from Here sends
their ~~love~~
especially Su Mei

ITALO SCANGA

961 Turquoise Street
San Diego, California 92109
Studio: 619 488 8546
Fax: 619 488 8562

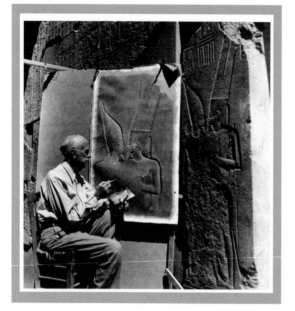

In June 1899, painter Joseph Lindon Smith lived in Magnolia, Massachusetts, and his sweetheart, Corinna Putnam, in Boston. He wrote a letter to her, enclosing a note to her father that asked for her hand in marriage. "I send with this, a letter I have written to your Father which, if you approve—you will send to him with yours won't you?" They married on September 18, 1899. Two months later they traveled to Egypt, where Smith painted archaeological artifacts. Known for his meticulous renderings of tomb interiors, temples, and ancient wall paintings, Smith traveled the world to study and paint archaeological treasures, with Corinna by his side.

JOSEPH LINDON SMITH
(1863–1950)

♥

CORINNA HAVEN PUTNAM
(1876–1965)

LEFT: Joseph Lindon Smith copying an ancient Egyptain relief of Tuthmosis III and Amon-Ra in Karnak (1504-1450 B.C.), ca. 1940. Photographer unknown. Miscellaneous photograph collection.

RIGHT: Joseph Lindon Smith to Corinna Haven Putnam, 26 June 1899. 3 pages. Joseph Lindon Smith and Smith family papers, 1647-1965. TRANSCRIPTION ON PAGE 122.

How I want to kiss you dear—how I want to feel you warm and sweet and loving in my arms — dear Carina—dear Corinna.

I love you—Oh I love you.

Monday night. 26th June

My own sweet darling girl,

How I want to kiss you dear - how I want to feel you, warm and sweet and loving, in my arms - dear Carina - dear Corinna.

I love you - Oh I love you.

I can hear the sea, breaking gently against the rocky coast, always a delicious song to go to sleep to. but now. the sea says words to me my darling, which it never did before - it says things about you, and love. and our happy life to come. and I feel you with me in spirit and I shall presently go to sleep. and we shall meet in our dreams. Oh my love, my darling love.

The sea - also tells me of the other lands, whose shores it kisses in these beautiful summer nights. of Italy. of Greece. and lands of Poetry and Fable. and it invites me out on its moonlit bosom. to seek those lovely places, and you - you Corinna - sweet brown eyed girl you are in the fairie boat. which waits out there to take me.

and go we shall dear. and I shall do my best to make your life the happiest you ever dreamed of. we shall see all the Old World's treasures: both of Nature and Art. and my arms will encircle you darling. and — well! it is all too much to write of. but we shall be happy. beyond all words of expression

Now it's morning and I'm lying here in bed. and you are in my waking thoughts dearest, as much as last night The sun streams in at the open window - and like the quiet, low murmuring sea last night. and the moonlight it makes me glad to be alive. and makes me think of you. which is the dearest picture I shall ever look upon.

I can see you lying in your bed. your pretty eyes shut - you can't be awake at this early hour. - when you wake up - it will be because I kneel at your bedside and whisper in your ear. "love love". while my arms steal around you - that's what wakes you darling those happy days "is n't it?" - your old faithful and loving Joe kissing you. and telling you another day has come.

I send with this, a letter I have written to your Father which if you approve - you will send to him with yours won't you: - and I shall now write to the three sisters and claim their affection. and tell them of my love for you. - will you send me their address please.

I shall go up to Dublin on Clara May's wedding day - Thursday - and you must come with me darling. I will write to Father to leave a boat over under the trees on the northern shore. and I will row you across to their

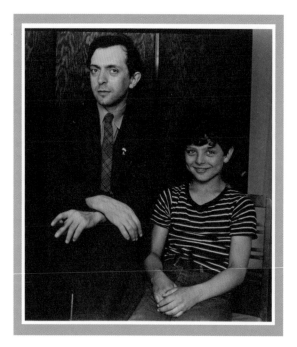

In the summer of 1940, social realist painter Moses Soyer, in New York City, sent colorful news to his only son, David, who was away at summer camp. The crayon and watercolor vignettes show one of the family's cats, Jester, in various states of animation. Soyer also reports on the New York Giants' winning streak. In another card he sends love and kisses from their other cat, Bright Eyes.

LEFT: Moses Soyer and his son, David, ca. 1937. Photographer unknown. Moses Soyer papers, 1920–1974.

BELOW: Moses Soyer to David Soyer, with illustration of Bright Eyes [1940]. 1 page. Moses Soyer papers, 1920–1974. TRANSCRIPTION ON PAGE 123.

RIGHT: Moses Soyer to David Soyer, with illustrations of Jester [1940]. 1 page. Moses Soyer papers, 1920–1974. TRANSCRIPTION ON PAGE 123.

MOSES SOYER

(1899–1974)

♥

DAVID SOYER

(b. 1928)

Having a good time—
so am I
Very Truly Yours Bright Eyes

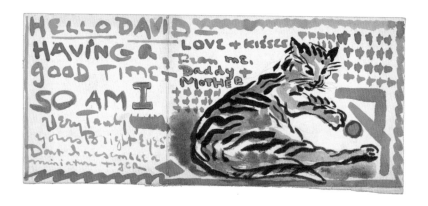

DEAR DAVID —

JESTER IS SITTING ON MY
TABLE AS I WRITE THIS LETTER.
HE IS PLAYING WITH THE
TELEPHONE WIRE, THE BOOKS
AND THE PAPERS. HE HAS
GROWN CONSIDERABLY SINCE
YOU SUSPICION LEFT, AND
IS AWFULLY CUTE AND
FUL OF. MISCHIEF.
YOU MIGHT
BE HAPPY
TO KNOW
THAT
THE

Ah do smell FOUL PLAY

GIANTS ARE
HAVING A SENSATIONAL
WINNING STREAK.
THEY WON SIX
GREAT GAMES
IN SUCCESSION.

RELAXATION

ALBERT STERNER

(1863–1946)

♥

MARIE WALTHER STERNER

(1880–1953)

In January 1899, painter and illustrator Albert Sterner was aboard the SS *Noordland* bound for Antwerp, Belgium. The SS *Noordland*, part of the Red Star Line, had been sailing weekly from New York City to Antwerp beginning in 1883. Seasick and lovesick, he longed for his wife Marie and their son, Harold. "Never before in my life have I experienced any sensations which are like the present ones; it is as if all the world had ceased and nothing would go on until I had seen and touched you once again."

Sterner was a seasoned traveler. He was born in London, and though his family moved to America when he was 15, he stayed with relatives in Germany, apprenticing in an iron factory. In about 1880, he rejoined his family in Chicago, where he worked for a lithography company. In 1885, he established a studio in New York City. His illustrations were published in *Harper's*, *Scribner's*, *Century*, and *Collier's* magazines. He traveled frequently to Europe and studied in Paris at the Académie Julian and the École des Beaux-Arts. He married Marie in 1895. They shared a deep interest in art—Marie opened her first art gallery in 1923—but it was not enough to sustain the marriage. They divorced on September 26, 1924. Albert was wed eight days later, to Flora Lash, secretary of the Philadelphia Print Club, on October 4, 1924.

LEFT: Harold and Marie Sterner, ca. 1900. Photographer unknown. Harold Sterner papers, 1929–1978.

RIGHT: Albert Sterner to his wife, Marie, 6 May [1899]. 4 pages. Albert Sterner letters, 1894–1916. TRANSCRIPTION ON PAGE 123.

Millions of Love and a thousand kisses all over you both.

On Board

S.S. Noordland

Saturday 4 pm
May 6.

My own darling Marie!
Although I
have had the strongest longing to
communicate with you ever since I
kissed you and our darling Bimby at
parting my condition has been such
that I could not until now do so. I
have been to be quite plain more or less
seasick & Thursday & Friday I spent
most of the day in my room. But my
seasickness my dear wife I assure you
has not been anything in point of severity
as compared with my constant feeling
of homesickness for you & Harold & Hartley.
This ship for some reason or other has
seemed like a prison and constant visions
of the lovely spring and our dear little
home rise up before me and I wish myself
back at your side again — But just as
it is a prison, so it is relentless the ship,
and speeds on its way bearing me ever further
from you and my baby! We are only
making fair progress — 256. 301 307 are
the runs. The company is in no way
interesting and the captain proves to be
what he looks just a seaman with little

JOHN STORRS

(1885–1956)

♥

MARGUERITE DE VILLE CHABROL

(1881–1959)

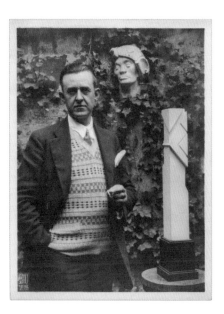

Sculptor John Storrs was ahead of his time. A first-generation modernist, he gave his geometric forms an elegant machine aesthetic that appealed to architects and progressive aesthetes alike. In 1914, he married Marguerite De Ville Chabrol, a French citizen, novelist, and correspondent for the Paris newspaper *Le Temps*. Perhaps appealing to her literary sensibilities as well as her obvious sexual magnetism, Storrs wrote her a passionate love poem that builds to a fervent climax.

Throughout his adult life, Storrs divided his time between France and the United States. In 1921, he purchased a fifteenth-century château in the Loire Valley, where he, Marguerite, and (for a time) their daughter, Monique, lived until his death in 1956. Twice imprisoned by the Nazis during World War II, Storrs was devoted to France and to Marguerite.

TOP: John and Marguerite Storrs, n.d. Photographer unknown. John Henry Bradley Storrs papers, 1847-1987.

BOTTOM: John Storrs in Paris, 1926. Photograph by Therese Bonney. John Henry Bradley Storrs papers, 1847-1987. Reproduced courtesy of the Bancroft Library, University of California, Berkeley, California.

RIGHT: John Henry Bradley Storrs, ca. 1914. Poem, 3 pages. John Henry Bradley Storrs papers, 1847-1987. TRANSCRIPTION ON PAGE 125.

My soul hangs upon Your
love — my lips burn to
touch your neck - your
eyes - your finger tips
to kiss each breast and
the hair that is so hot
between Your legs —
to kiss - to kiss each
drop of blood - as steam-
ing red it surges -
pulsing - throbing through
Your heart ———
I lay my lips upon
your soul -- until
"I come"

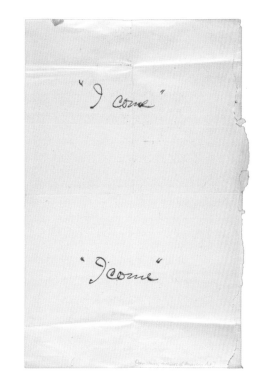

"I come"

"I come"

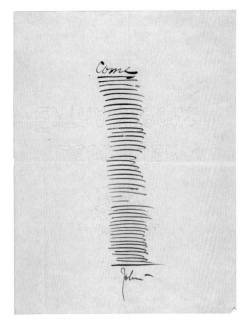

My soul
hangs upon your love —
my lips
burn to touch your neck —
your eyes —
your finger tips.

LENORE TAWNEY

(b. 1907)

♥

MARYETTE CHARLTON

(b. 1924)

A celebrated figure in the field of fiber art, Lenore Tawney made woven sculpture. In the 1960s, her friend, filmmaker Maryette Charlton, sparked her interest in creating postcard collages, which she sent to friends and colleagues. Tawney's artful communiqué to Charlton centers on the subject of pandas kissing. Her meticulous handwriting weaves together quotes from nineteenth-century naturalists Frédéric Cuvier and J. G. Wood, as well as from writer Gertrude Stein, to make a whimsical riff on a kiss.

LEFT: Maryette Charlton filming Lenore Tawney, 1977. Photographer unknown. Maryette Charlton papers, 1929-1998.

BELOW AND RIGHT: Lenore Tawney to Maryette Charlton [postmarked September 1977]. 1 postcard. Maryette Charlton papers, 1929-1998. TRANSCRIPTION ON PAGE 126.

a kiss
a step
a thousand
miles

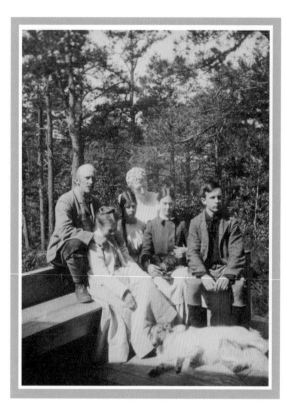

ABBOTT HANDERSON THAYER

(1849–1921)

♥

EMMELINE BUCKINGHAM BEACH

(1850–1924)

Painter, naturalist, and teacher Abbott Handerson Thayer was devoted to his family. He adored his wife Kate and their three children, Gerald, Mary, and Gladys. At various times he immortalized the Thayer women, who posed for his paintings of earthbound angels with heavily feathered wings.

When Kate died in May 1891, Thayer was devastated. He turned to Emma Beach, an artist and close family friend who had looked after Kate and the children and helped manage Thayer's business affairs. In August 1891, Thayer wrote to Emma (whom he called "Addie") about their impending marriage, describing how their passion caught fire through their letters: "I threw a fire brand at Addie and she hurled it away and assured me it hadn't caught her clothes, but lo a spark <u>did</u> catch and in each letter behold her more and more in flames!" While both Thayer and Emma seem to have worried about marrying too soon after Kate's death—"my moral sense like yours says be calm and endure gratefully one more month for a lot of little reasons"—they impetuously married on Nantucket Island in Massachusetts, six days after this letter was written.

LEFT: Abbott Handerson Thayer and family on their porch in Dublin, New Hampshire, ca. 1905. Photographer unknown. *Left to right*: Abbott Handerson Thayer, Emma Beach Thayer, Gladys, Mary holding Hermes [the cat], Gerald, and Hauskuld [the dog] in front. Nelson and Henry C. White research material, 1898–1978.

RIGHT: Abbott Handerson Thayer to Emma Beach, 28 August 1891. 4 pages. Abbott Handerson Thayer and Thayer family papers, 1851–1999. TRANSCRIPTION ON PAGE 126.

Sat. Aug 28.

My dear, my darling
all the joy, (that happens
to be at flood tide this a.m.
in me), health restored sleep
heavy, and full appetite and
the sense of having possibly
an actually great picture here
all this I pour into your heart this
morning — I have the ring diagrams,
there seems to be no compelling
reason yet my moral sense like
yours says be calm and endure
gratefully one month more
for a lot of little reasons

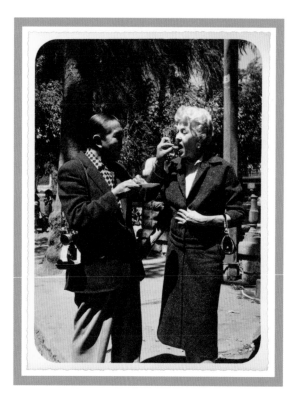

Peruvian-born Alberto Vargas was famous for his watercolor and airbrush pinups that appeared first in *Esquire* magazine, from 1940 to 1947, and later in *Playboy*, from 1960 to 1976. His idealized nudes, known as *Esquire*'s "Varga Girls," and spin-offs such as the Varga Girl calendars, were wildly popular among GIs during World War II. He met his wife, Anna Mae Clift, in New York City in 1920. A striking redhead, she was a showgirl in the Greenwich Village Follies, and Vargas asked her to pose for him. They married ten years later. She was his true love, his model, and his aficionada throughout their forty-four years of marriage.

LEFT: Alberto and Anna Mae Vargas, 1958. Photographer unknown. Alberto Vargas papers, 1914–1981.

BELOW: Alberto Vargas poem, "To my Ana," n.d. 1 page. Alberto Vargas papers, 1914–1981. TRANSCRIPTION ON PAGE 126.

RIGHT: Alberto Vargas with his pinup girls in a hotel in Amsterdam, ca. 1978. Photograph by Steye Raviez. Alberto Vargas papers, 1914–1981.

ALBERTO VARGAS

(1896–1982)

♥

ANNA MAE VARGAS

(1897–1974)

Your dim, tender voice distilling Lust into the brain:
My thoughts of you—in you to loose fore'er and e'er….

PATTI WARASHINA

(b. 1940)

♥

ROBERT SPERRY

(1927–1998)

Patti Warashina is best known for her low-fired, highly colored, whimsical clay sculptures. She first met professor and fellow ceramist Robert Sperry in 1959, when she took his design class as an undergraduate at the University of Washington in Seattle. Patti also attended graduate school there, married her first husband, moved to the Midwest, taught, returned to Seattle, and divorced, before reconnecting with Sperry in 1970, when she too joined the faculty of the University of Washington's ceramics department.

In an interview Patti remarked, "Bob worked quite differently than I did. I mean, he was [an] abstract expressionist in clay and I was doing this kind of realism, and we never really had a conflict...we were really comfortable with each other's integrity about our own work. And I think that is kind of the main thing about being an artist, is that you're able to say whatever you need to say without this friction in your marriage. And so I think that...kind of permeated the studio."

Patti often sent playful handmade cards to her husband. In a 1993 valentine, she made an alluring photo collage of Bob encountering her half-naked in a maid's costume on the beach, while a 1996 valentine consisted of a spinning pinwheel of multiple images of herself affectionately licking Bob's face with each revolution.

LEFT: Patti Warashina to Robert Sperry, 14 February 1996. Handmade valentine, 1 page. Robert Sperry Papers, 1951-2002.

RIGHT: Patti Warashina to Robert Sperry, 14 February 1993. Handmade valentine, 1 page. Robert Sperry Papers, 1951-2002.

My head swirls when I think about you, Bob!

SARAH BALDWIN WARNER

(1819–1891)

♥

OLIN LEVI WARNER

(1844–1896)

In 1859, Sarah Warner responded, with a mother's love and anxiety, to a letter from her son, Olin Levi Warner—the first letter she had ever received from him. Olin was 15 and away at a private school in Florida, New York. Sarah, the wife of a preacher and a preacher herself, writes a prototypical Victorian letter, full of admonitions about God, duty, gratitude, and hard work. Olin was staying with Sarah's sister Elizabeth, whose husband was the principal of the school; and it was only through their kindness that he was briefly afforded a private education.

This was not the last time that Olin would travel for his studies, though. He became one of the first American sculptors to attend the École des Beaux-Arts in Paris, which he entered in 1870. Reflecting his training in Parisian modeling techniques, Warner's sensitive portrait reliefs and busts are prime examples of the influence of the French school.

LEFT: Olin Levi Warner in his New York City studio with one of the caryatids (in plaster) for the *Skidmore Fountain*, ca. 1887, installed in Portland, Oregon, in 1888. The fountain is named for Stephen Griggs Skidmore (1838-1883), a Portland druggist who bequeathed $5,000 to the city for a fountain where "horses, men, and dogs" might drink. Photographer unknown. Olin Levi Warner and Warner family papers, 1862-1963.

RIGHT: Sarah Baldwin Warner to Olin Levi Warner, 25 June 1859. 4 pages. Olin Levi Warner and Warner family papers, 1862-1963. TRANSCRIPTION ON PAGE 127.

I traced each line with an axious eye,

for your mother forgets not her first born — the one

who coccupies a large place in a mothers heart.

1859

Gloversville June

My dear son Olin

I was much pleased with a letter which came to hand some days since, when on opening to my great joy I found it was from the hand of my absent boy The first that my son has ever written to his mother. I traced each line with an axious eye, for your mother forgets not her first born — the one who coccupies a large place in a mothers heart. my thoughts often wander to the place where we believe you are trying to get an education, and we feel quite sure you will try to improve the precious hours God gives you, as also to appreciate the labor bestowed upon you by your kind and very en- dulgent friends, I mean your dear uncle and aunt, Were it not for their indulgent and affectionate regard certainly you could not be there.

Granmother Jeffers was buried last april, also the grandmother of Hedding Putnam. Mr Shaw the blacksmith is just alive with dropsy. Pleasant valley has changed very much, Father Orton is broken up and now lives with his son Lorenzo the good old Lady often spok of you and desired to see you and your father, bent she has left this world of sorrow in a good old age, She died rejoicing in Jesus as her only sure trist in the dying hour, She had for years been trying to trust in the Redeemer and he forsook her not in death, The whole of Rockwood mourns for her, she was greatly beloved. Precious friend to you, to us all, We can only visit the spot where those sacked ashes lie, and write Farewell over the dust of her we loved, and leave her to sleep on, Till God shall wake the sleeping dust. May you my dear son ever remember the good advice which she gave you and early begin to love the Lords fearless of all the opposing in- fluence around you, give that young heart every day to God, Pray to be kept from evil influence around you. Remem- ber your mother prays much for Olin, Present my choice love to your Uncle and Aunt, love to German Libby also. write immediately giving all particulars Father joins me in love to our absent boy

Your affectionate mother J. Warner

Born into immense wealth, sculptor Gertrude Vanderbilt had many suitors. Chief among them was Harry Payne Whitney, whose family was almost as rich and socially prominent as the Vanderbilts. In 1896, when Gertrude was at her family's summer home, the Breakers, in Newport, Rhode Island, Harry courted her through progressively passionate letters. They married on August 25, 1896. In 1914, Gertrude established the Whitney Studio Club, which evolved into the Whitney Museum of American Art, founded in 1931.

LEFT: Gertrude Vanderbilt Whitney with her sculpture *Despair* (1917), n.d. Photograph by Jean de Strelecki. Gertrude Vanderbilt Whitney papers, 1855-1975.

BELOW: Harry Payne Whitney to Gertrude Vanderbilt, ca. 1896. 4 pages. Gertrude Vanderbilt Whitney papers, 1855-1975. TRANSCRIPTION ON PAGE 128.

RIGHT: Gertrude Vanderbilt's scrapbook, ca. 1893-1896. 60 pages. Gertrude Vanderbilt Whitney papers, 1855-1975.

HARRY PAYNE WHITNEY

(1872–1930)

♥

GERTRUDE VANDERBILT

(1875–1942)

THE WORLD: SUNDAY, JUNE

$1,500 a Year Enormous

LIONAI

Miss Vander Like Other Foreign Stars

HARRY PAYNE WHITNEY AND HIS CHIEF INTERESTS IN LIFE.

HARRY WHITNEY
LIKES SPORT BEST.

I love you & want you & need you
& only you & more all the time.

Transcriptions

Florence Ballin to Konrad Cramer [1911]
Letter, 1 page, handwritten
Konrad and Florence Ballin Cramer papers, 1897–1968

"Oh my beloved" Do you not hear my heart calling you! I lay awake long hours thinking last night, and then I dreamed again, a strange dream. It is long since I have had sleeping dreams, tho waking ones I am never without. I still feel as if it would all suddenly melt away, this great happiness—but it must not dear heart, it would be too cruel and I do not want to suffer so.

Come and let me look at you and know that it is real. That I am Florence Ballin and you are my dear Comrade, my sweet playmate and not some magic person who might disappear at any moment.

Gifford Beal to Maud Ramsdell, 19 December 1906
Letter, 5 pages, handwritten
Gifford Beal sketches, sketchbooks, and papers, 1902–1953

Dec. 19, 1906
Dearest Girl,

Father has just returned from Newburgh [New York] and says that it was snowing hard up there this morning; although it has been raining here all day. So I think if that is so I will go up there soon because I want to get some snow scenes. The Highlands are so beautiful in this kind of weather; I mean when the hills are covered with snow. I want most of all to get early morning effects when the sun is just rising and the light is hitting the tops of the hills. The worst part of it is I am such a late riser in the mornings. It's very hard for me to get up and I'm a bad boy. But when I go up I'll make an extra effort. A good way to get up early is to go to bed early. You know last year I got to know quite well the station master at Storm King station. He lives in a little house quite near the tracks, well I think I'll write to him ask him to put me up for a couple of nights so that I can be right on the spot in the mornings. He is a funny man and quite interesting as he is fond of taking photographs of Hudson River scenes. I am afraid I will keep awake from the noise made by the trains thundering through the tunnel.

One of my best friends is going to get married next week and he lives just above me in the studio building. When he marries is going to live in his apartment with his wife. He has been a great help to me because he talks straight and generally says just what he means. He tells me just what he thinks of my pictures when I paint them and that is a great help. He very seldom flatters.

To night I took out a big map of The United States and look at the state of Texas to find out exactly in what part of the state you were. The nearest point I found was Del Rio. The place you have spoken about in your letters. I found that you were very near the border line and the Rio Grande river and it was not at all in the same part of the state I expected it to be. I look at the map so eagerly and it seemed to bring you very near me Sweetheart.

I find that I can take the Mallory line to Galveston and get to Del Rio by a very direct route right across the state. I will probably be with Albert part of the way as he is fond of the sea trip and is counting on going to Mexico. He makes a fine travelling companion as we get along famously together. You will probably get this letter just about Christmas

Good night Sweetheart. I long to see you again. I hope it does not look ofenceive (pun). With all my love
Gifford.
Please excuse blots in middle of this letter

The Mallory Line is the Mallory Ocean Liner, also known as the New York and Texas Steamship Co.

Max Bohm to Zella Newcomb Bohm, 19 April 1912
Letter, 7 pages, handwritten
Max Bohm papers, 1856–1964

S. S. *Rochambeau*
April 19, Friday 1912

My Dear Teeky Teeky Darling,

We have been nearly a week now and we have had pretty bad weather all the time with most people sea sick and I did not escape it either. I fought against it and treated but I had to go like the rest, but it was bad only one day and I only missed one meal having been forced to leave the table. We made up a table of those people whom you saw in our railroad compartment plus one young man. At first I thought I was unfortunate that I was not at one of the other tables but it all turned out all right and we had quite interesting conversations. Mrs. Buehr was sick a lot and so was the baby but the Bretyes mother and daughter were spry all the time and we got very well acquainted. The young man a swiss just sat at the table and said nothing.

We have good white and red wine thrown in and that makes the conversation go. Between meals I walk around and play a lot of chess and am mostly victorious. I miss you very much and this morning I have a kind of a home sickness and wish the ship were going the other way very hard. This is a rather smooth sea this morning and I can write. We have a lot of immigrants on board and in the second cabin too but they make these people eat an hour and a half before the civilized people, so that when we eat the place looks like a first cabin. We have very good food and I have a beautiful cabin all to myself. Mrs. Buehr told that I am a C. S. and the people try to make me talk about it but I wont. I walk the ladies round the deck and give them the necessary exercise. Mrs. Buehr walks the best but she does look a fright when she is sea sick.

Saturday

We had news of the terrible disaster which happened to the White Star Steamer Titanic some days ago. Yesterday we had great excitement on board for we saw seven or eight big ice bergs and we came within a few hundred feet of some of them. They were ugly looking big chunks of ice I can tell you. We were very close to one which was 1500 feet long and 1000 ft broad. At the time the weather was clear and we had a good view of the things. After ward we had a gale come up with thick fog. All day today we had big seas breaking over the bow of the steamer and the spray flying all over it. It has been a rough trip. Some people havent been up yet.

Sunday.

We have just had the medical visit. You see we are second class people going to America and they want to know all about us. The sea is smooth and we are having American weather, clear and crisp. I am quite miserable because I would like to take the next steamer back to you and cant do it. I have you and the children before my minds eye all the time and you can just bet that I wont waste any time before I get my return ticket. I have not had much benefit of the trip but am very nervous. This trip was not a rest. I will send on my box to Cleveland by express because they wont take it as baggage any way and I also dont think it will be safe to let it hang around New York while I am attending to things. The express Co will also insure it.

We will land early tomorrow morning. I have to get money changed and pack up and do a lot of things yet. So my dear dear Teeky kiss all the children for me and tell them that it was good to read their letters when I was in the middle of the ocean. I love you all very much and tell the children to be good. I am so glad you are in that apartment and that all was fixed before I went. I will send you some money just as soon as I have some.

Now you dear Teeky, dont worry but say a prayer for your Pa Pa. Do not worry!!! I wish you were all with me. It would be a comfort but I am now going to do the best I can for you all.

I love you dear many kisses to you darling from your
Max

C. S. means Christian Scientist.

Paul Bransom to Grace Bond [1905]
Letter, 2 pages, handwritten, illustrated
Paul Bransom papers, 1862–1983

Thursday—

TRILBY!!!
TOUJOURS-AMOUR

My Gracie—

You had better not be a wreck by the time you reach Wash. (think how it will be by the time you leave).

I'm so glad Nora approves. Of course I was very anxious over the effect of our interview & was so worried for fear she would not. I will be at the station at 8 o'clock Sunday morning & I'm sure—nothing short of a team of horses & a log chain—will be able to persuade me to leave before your train comes in. Having been reading Trilby again today. I never tire of it—& I'm going to read it to you (minus the French) during the cozy long winter evenings we shall be together.

Have you any idea where our flats going to be—? I haven't—but I do have an idea that if I don't get to work & think up some ideas this afternoon, that there may not be anything. Yours with adoring love.

Paul

Nancy Douglas Brush to Robert Pearmain, 17 August 1909
Letter, 4 pages, handwritten
Nancy Douglas Bowditch papers, ca. 1900s–1970s

August 17th 1909

Dearest Robert—

Alas I have received your bad news letter! The only one I have had since you went away and it now makes me feel that I wish you had never gone away. But I'll tell you one thing, dear Robert, that I feel perfectly calm and quiet in my mind and can tell you Just what I think we'd better do. Get married on September the 11th, and I'll telly you why. You know that I am not over happy in my family in these days and so to get married

no matter how hard I have to work is my only aim now and I would be more than heart broken if it had to be put off. Darling, I must be near you and live with you! I think that everything had better go on as we had it all planned about our weding. It would be too great a change not too. We will begin working hard right away and papa will get you a job some where and we will settle down this winter in the Buck house and see how much money we can earn. You know what papa says about my work. You know that you can get work and earn money if you try hard enough and Robert, let us undertake suporting ourselves no matter how hard rather than not to get married after all this waiting! Please please dear Robert, will you? I haven't talked with papa yet, but when he comes home I will have a good talk with him and then write you a good letter telling all he says etc. For the moment this letter is to quiet your heart a little. You are a fine man and I am proud that you stick up for yourself that way. I love you very much and will love you even more when I am your wife. I must be your wife no matter how hard life may come to us. I wish to share hardships with you. Let us be married and then be as independent as we know how too. I think your father looses his temper just as papa does but I don't really think he would do anything very bad. We will be as hard working as we know how to – I am willing to go anywhere you like when we are married. You are the master of what we do, all I ask you is, make me your wife, your own true little love. Nanc

The Buck house was a cottage in Dublin, New Hampshire, that belonged to Robert Pearmain's aunt, Mrs. Osgood. After Robert and Nancy married they lived there.

Dennis Miller Bunker to Eleanor Hardy, ca. 1890
Letter, 11 pages, handwritten
Dennis Miller Bunker papers, 1882–1943

3 North Washington Square
Wednesday

My own sweet Eleanor.

I have just unlocked my little box and found your letter—and the world has drifted off a thousand miles and left me alone with you again. Yes dear your love does cover and shield me and it has so woven itself into my life that I can't imagine how I could live now without it. You have made me feel all the sweetness and dignity of life and all my poor old worn out bitter feelings, distrust and doubts seem very dim and far off now. The last two or three years I have felt so tired and discouraged some how, so puzzled by many things that it seems like being born again to have your sweet love come to me now, and to feel as I do every moment the passionate longing to be near you and to trust you and to rest at last in your dear loving heart. I can never do for you my sweet what you have for me. I have made so many mistakes—tried so many things, failed so often, and have been so many years alone, that you came to me as the one supreme blessing life could give to save and support me. The blessing of a pure girl's love that turns a man's mind from his own troubled heart and tiny cares to love and rest in the life of another. It seems to me sometimes that I ought to be much younger, much fresher and full of hopes and illusions to be everything to you, but I think then that I should not love you as dearly and as steadfastly as I do—Oh—I do love you so much every moment and day seems incomplete without your sweet presence. My arms tremble to hold you again—and sometimes in the night it seems as if I could not stand it any longer and that I must turn and hear your beloved voice and feel your dear hand stroke my hair again. My own precious love, how sweet it will be to see you again. I wonder when you know me through and through what sort of crazy person you'll think me. I don't care much if you only keep on loving me, that would be now the only real misfortune in the world, to lose your love. But you won't lovely Eleanor will you! Will you love me when I'm stupid and cross, when I fail and make mistakes and worry you with my questions and doubts. I know you will, dear little girl, dear little

Eleanor—do you know that I've been sick ever since I came to New York? I've had the most dreadful cold and sore throat and head-ache—unable to think or see—I think I'm a bit better this morning but I look as if I'd been starved for a month—I'm glad you can't see me. You'd be disgusted—I look like a small fat french toad with the dyspepsia. This is a latin simile—you'll find it in Horace, p. 300 xiii—I take medicine—for forms sake—every two hours, because I know you'd make me, but of course I like other medicines it is useless.

I love you most dearly [highlights with a square around].

I find that I am not sufficiently shameless to offer you any of my existing sketches, they are too frantic and would frighten your family and give Roger convulsions. I would fain offer to kiss you instead, in my own little place in the side of your lovely neck—but alas! tu es bien loin, et j'embrasse le vide [You are far away, and I kiss emptiness].

Mrs. Fairchild and Lucia were up here yesterday—they both looked very pretty—I don't know which was the prettiest. Mrs. Fairchild asked me to come and stay with them.

I love you so just now that I can't breath [highlights with a square around]

When I come to Boston they are always so good to me and do so much for me—Have you told your friend Miss Otis that you've thrown yourself away on a foolish painter—who has nothing in the world but love and a red veil to his name? Don't worry sweetheart about your music—there are times in art when the impossibility of progress seems final—but I'm sure that those times come to us all and that we have to support them as best we can—you are probably making more progress than you imagine—you know I live in a chronic state of that sort of thing. Your marvelously accurate dream about me the other day is peculiarly applicable just now, for I truly

I kiss you a thousand times my darling love [highlights with a square around]

do nothing but wander about in a shabby coat with a palette in my hand and lovely Eleanor in my heart. Platt my neighbor is amazed at the amount of time I can spend doing nothing, just as if thinking of you were an unimportant occupation or one to be in any way hurried. I assure you my beloved that I don't hurry. I must stop writing now. I will tell you when I am coming just as soon as I know myself. Will you be glad to see me?

My own dear love, think often of me—I send you a million kisses—I haven't much love left over—but will you give what there is to your mother and sister? Send me a letter as soon as you can get one written. I love you sweet.

Dennis

Mrs. Fairchild is poet and literary hostess Elizabeth [Lily] Nelson Fairchild (1845–1924); Lucia is Fairchild's daughter, artist Lucia Fairchild Fuller (1872–1924). Platt is Bunker's friend, painter and landscape architect Charles Adams Platt (1861–1933). In 1893, three years after Bunker's death, Eleanor married Platt.

"Rev." Royce Dendler to Ellen Hulda Johnson, ca. 1971
Letter, 1 page, handwritten
Ellen Hulda Johnson papers, 1939–1980

Dear Ellen,

Enclosed is a Love Charm
[And especially extra for you—some of my literature!]

Through Psychometry I received that you are a person who knows Herself, both strengths & short comings. I also received caution about your using the color blue for appliances and napkins and things of that sort. The spirits add, "you should be kind to those lower than you." A person from the other side w/ initials M.(D.) says "he is proud of you."

Your lucky number is "9"

Ohio previously acknowledged expert palmist is the librarian at Grafton Library (housed at the High School). You ought to meet her definately. Incidentally, the Grafton Public Library has the best Ohio Library on the Occult because of the above mentioned: Dorothy L. Sneclaker (211 "8" St. Elyria Ohio or Grafton Library).

Rev Royce Dendler

Alexander Doyle to Fannibelle Johnson, 11 May 1879
Letter, 3 pages, handwritten
Alexander Doyle papers, 1852–1937

New Orleans, 5-11-1879

My darling,

Your dear letter has just been placed in my hand by the aforesaid clerk of the Hotel who was gracious enough to bring it up to the room himself.

I have just finished casting my figure and am over head and eyes in plaster, so if anything disappoints you in this letter don't blame me severely, dear.

Please don't grieve if I am not back in Hallowell [Maine] by Friday night, you don't know how I should like—like, oh! ever so much to be and certainly would were it possible, but I cannot leave here before tomorrow, Tuesday night and, Fannibelle there are two places I must stop on the road a day. Oh! Fannibelle if you knew how my heart aches to see you you'd not think that I stay a moment of time more than necessary away. If I could come by telegraph I would be with you in a few minutes but my darling, reason must as it always should gain the day over blind desire. If I stay away be assured that it is to gain some point and I have more courage to do this when I think that in ~~benefitting~~ gaining myself you gain also. If my own gain only were at stake I would throw it all to the winds to reach you one day sooner, but Fannibelle the future of both of us is at stake. As it is I have to fight to leave here now so soon. Father's agent calls it sheer madness (he doesn't know the reason poor fellow). He says if I would stay a week longer he could get me some important commissions but I told him I would not stay here to execute them anyway so he can get them as well with me away as here.

But I am so busy Fannibelle I know you will pardon this short letter and believe me with great love.

Ever yours
Alex D.

Alexander Doyle's father, George Doyle (d. 1898), was part owner of the Hinsdale Doyle Granite Company, which served as a ready supply of stone for the sculptor.

Frank Vincent DuMond to Helen Xavier [August 1894]
Letter, 6 pages, handwritten
Frank Vincent DuMond papers, 1866–1982

Sweetheart,

Just think of the accident which has happened to me. I enclose a couple of slips cut from the Telegraph News of the Paris edition of the New York Herald, which will explain it all —So I've really been burned out. What shall I do when I go back to New York City? Everything I had in the world was in that studio and I am afraid to sit down and think over the different things which are probably utterly ruined. Just imagine how the dear old place must look with the charred and ragged remains of all my rugs and the stuff which covered the walls and the sofa cushions with the feathers half burned and scattered about. Yes and the winter clothes hanging on the hooks or in wads on the floor—all soaked with water and mingled with broken window glass and stinking with smoke. There too is the chest of drawers, my big easel, a thousand photographs, some of Ross's pictures and frames and some of my brother's too. My poor old fish net and fire screen and the photographs of the old master's in the long frames. Yes and great Heavens! Everything behind the curtains in the back end of the room—well let them go if they are really gone—I don't care a straw, one might as well be sensible and merry and commence over again. What ought I to care, thank you dearest (kiss me) and since we are going to begin over again together soon why its a fine thing to think of leaving all my old world behind and beginning in a new and better one. I must own to feeling the loss of the dear old place and objects which know you and almost talk to me about you and then too, to think that you may never sit on my knee again in the beautiful mellow light which that place had—well that part of it, dear, is hard— you see I do count upon your coming to New York this coming winter in spite of everything—How is the law suit coming out?

As I wrote you we had arranged to have my father and mother go through Italy and return home by the way of Naples, but as the time was so limited we found tiring poor father and he is therefore still with us. He is going to sail for New York next Tuesday—I am going to give him something which he will mail to you when he arrives on the other side. Poor Father! I know that you may never see him dear. I am going to photograph him to-morrow and will send you a proof print! I enclose in this letter a little group which I made in our hotel courtyard. When I tell you that the girl with the white waist and sailor hat is a pupil who has known my mother for years, you will know that the others are my mother and my brother and sister and the baby—It's a pity that the photograph doesn't show how red the little chap's hair is but you can plainly see that he is an eel. There are some other photos of the family which I shall send later. So you have gone to the sea shore to visit your friend—Yes I should say I do regret that I am not there with you. How is it anyway that providence is bitter enough to put you where I cannot be, when my every day is a most fervent prayer against it. But our fun will come at last and I am going to have a year's vacation in which to get even. How sweet it was of you to have arisen at five in the morning to write to me – so you had cold feet and sat upon them and you had on your little pink wrapper—dear dear me! don't let me think of such things I forget to keep on writing—I shall sail out of the window. Here's a kiss for every little red toe you have.

I have just returned from Paris where I have been to ship my drawings for the Jerusalem article, to Harpers. I'm glad to have that work out of my sight but the consolation is but skin deep as I shall have to keep right on with the Italian article.

My illustrating is not yet half over.

No dear I have never read Ouida's "Ariadne" but I know a little of the opening chapters of the book. I put my thumb out of joint yesterday and it is twice as large as it should be but I shall try to give you an impression of it just the same. Well baby have a good time at the sea shore and think of yrs and write to your best beau. [Four *k*s in circles] Frank

P.S. All the thumb impressions have been kissed, now it is your turn to press your own lips and dirty thumb to the letters you send to me.

Ouida, the pen name of Louise de la Ramée, was a popular late nineteenth-century novelist. Ariadne was published in 1877.

Styrbjörn Engström to Duane Hanson, 10 April 1975
Letter, 2 pages, handwritten, illustrated
Duane Hanson papers, 1969–1995

STOCKHOLM, SWEDEN
10.4 1975

HALLO! [drawing of flower]

YOU DON'T KNOW ME, BUT I KNOW WHO YOU ARE.
NOT IN PERSON, BUT I KNOW YOURE FANTASTIC
ART.

 MY NAME IS STYRBJÖRN ENGSTRÖM (IT'S AN
OLD DIFFICULT SCANDINAVIAN NAME, PERHAPS
"STEVE" IS BETTER FOR YOU,) AND THIS EVENING I
AM SITTING IN A FLAT HERE IN STOCKHOLM, (I'M
WATCHING A BABY TO MY FRIEND) AND TRY TO
MOULD SOME WORD FOR YOU! YOU SEE, MY WISH
IS TO COME IN CONTACT WITH YOU. THAT'S WHY
YOU HAVE THIS LETTER!

 I AM 29, AND IS WORKING AS A PAINTER AND
ALSO AS A DESIGNER IN FILM/TV. JUST NOW I'M
DOING WORK AS A DESIGNER FOR "THE ROYAL
THEATRE OF DRAMA" HERE IN STOCKHOLM. I HAVE
BEEN AT DIFFERENT ART-SCHOOLS, AND WAS FOR 5
YEARS AT THE "ACADEMY OF ART" IN STOCKHOLM.
YOUR WORK HAVE MEAN A LOT FOR ME, IN
MANY WAYS!

 TO THE POINT! MY QUESTION IS, (I hope you don't
think it's a insolent question) IF IT IS POSSIBLE FOR ME TO
SEE YOU WHEN I COME TO USA FOR A 4 WEEKS
HOLIDAY. MY MOTIVE FOR MY TRIP TO USA IS TO VISIT
SOME FRIENDS, HAVE IMPRESSIONS, EXPERIENCE
AND IF ITS POSSIBLE MEET YOU! I'M PLANING TO
GO TO NEW YORK, ROUND 20.5 (20TH MAY) AND GO
BACK TO SWEDEN AROUND 20.6 (20TH JUNE)

 I KNOW THAT YOU PERHAPS IS VERY BUSY, BUT
IF YOU HAVE TIME, I WOULD BE A VERY HAPPY MAN,
IF YOU SEND ME A CARD/LETTER AND TELL ME
WHERE I CAN FIND YOU, (ADRESS AND PHONE)

O.K. THAT'S ALL! I HOPE YOU WILL HAVE A NICE
TIME, AND THANK YOU FOR READING THIS.
YOUR: [drawing of sun]
 STYRBJÖRN ENGSTRÖM
 ÖSTERMALMSGATAN, 64
 11450 STOCKHOLM
 SWEDEN

(PLEASE SEND ME THE CARD/LETTER AS SOON AS
POSSIBLE)/
[signed] Styrm

(P.S. I HOPE MY ENGLISH ISN'T TOO BAD DS)

Beatrice Fenton to Marjorie D. Martinet, n.d.
Letter, 1 page, handwritten
Beatrice Fenton papers, 1890–1983

Sat. evening 6 p.m.

My best Beloved;—

 The lovely, fragrant hyacinths have just come—a large pot
of beautiful radiant white ones! How dear of you to send them! I
was just in the act of playing Shubert's Serenade when they
arrived,—to still or express an indefinable longing, and thinking
of you Beloved, and how you liked it.

 Many thanks, dear, for your loving thought and the beautiful plant.

 I would pour out to you the tenderest and the most fervent
love I know if you were here to-night, Beloved. I wish I could
do more than write it, or ~~at~~ that I would write poetry.

 You are so dear, Marjorie!

 With a thousand kisses—

 Your

 Beatrice

Marjorie D. Martinet, May 1915
Poem, 1 page, handwritten
Beatrice Fenton papers, 1890–1983

My love is like the sea;
returning—as the tide—

Out far out I know not wither go my love then as the tide.
Far, far, called by the moon, mad muse.
Ebb, ebb, ocean ward a call unhuman do I harken unto
To that great vast expanse of endevor do I go—

But then also as the tide my longing turns landward
Ardent then my love, on, on, returning.
Sweet land! nearer, nearer, higher, higher,
Fair cliff mine kisses know; dear earth beloved beach!

Upon the breast then of the beach weary the waves find peace
Sweet beach of all my wandering hopes; I whisper softly.
Lovingly with embraces pleading
Gently then with kisses speaking, unto the lovely shore, your love.

To my friend B.F.
May 1915
Marjorie D. Martinet

Alfred Joseph Frueh to Giuliette Fanciulli, 26 November 1912
Letter, 6 pages, handwritten, illustrated
Alfred J. Frueh papers, 1904–1993

Paris, Nov 26 1912

Dear Guiliette
 Took your letter away from the Express Co this A.M.
Havent got time to Answer 2 darn Busy, Good night.
 Same
 Old

P.S. Yep. I'm pretty busy and I'm awfully Homesick, Putineer
dead. The doctor put me on a diet. Cant eat nothing but figs.
Mother Taught me never to eat any fruit unless I first picked
out the seeds.
P.S. Now do you think Im busy?

P.S. One of the churches gave an entertainment – I saved the
programme for you Will mail it. Pretty bum entertainment.
Would have enjoyed it much more had some dandy body like
you been along.
P.S. ↑still showing the effects of "Post Office" with that Blarney stone
P.S. Of course your dream about coming over here is true.
P.S. 'Cause I want it to be
P.S. —over.
P.S. Im going right down to the doctor and wait for you.
P.S. Let me know quick the exact date of your coming so I can
begin to count the days
P.S. I dont know for sure just where I'll be in the spring but if
I'm within a thousand miles of this town I'll come here if you do.
P.S. I would sooner be where you are when you're there, than
lots of other places
P.S. I mean places like "Any place else", "Any other place", and
"Any place in the world"
P.S. Take your pick.
P.S. No. I dont mean, and I did n't say "Any old place"
P.S. I am only in Paris because I'm waiting. The Legion of
Honor is going to send for me soon. They want me to wear
some of their medals, I think.
P.S. Gee Girl. If you treat all your friends when they sail as well
as you treated me, you must be a pretty busy girl buying books
and good things to eat, and clipping the magazines
P.S. You're far too busy to be a reading this junk
P.S. I'm going to stop soon
P.S. Dont you wake up till your dream comes true. Now Paris is
"crazy" to see you.
P.S. And so am I.
P.S. I hope it aint "only a dream"
P.S. Now. Do I have to shout for the suffragette party?
P.S. I am sure sorry I missed that Shoe black. Goddess.
P.S. You bet, I would sooner have the "pinkies" than the "blues".
P.S. Here's a nice little testimonial
CASE NO () I dont know

Paris France Nov 26/12

Dear Doctor Juliette: –

For over 15 years Ive suffered with a cronic case of The Blues.
I have tried many remedies Blonde and Auburn, without
permanent relief

Since I began taking your "pinkies" I can smile without
a pain.

I will never take any other.

Very truly yours,

Alfred J. Frueh

P.S. Gee a "peach" just passed the window you ought to have
seen it.

P.S. —Send me back my heart right away

P.S. Me and Mutt. We're scrapping again I said the Zoo in New
York has a collection of Mock Turtles and mut says they havent.
I wish you would find out and let me know. He wants to bet me.

P.S. "Pleasant dreams"—Rats—Everytime I do, you're gone
when I wake up

P.S. I wish I had a celestial music box.

P.S. Excuse my hurry, wont you?

but I gotta go now—

P.S. Cant tell you any more gotta save some for next time.

PS. Come early in the spring

PS —Good Luck [three horseshoes and a four leaf clover]

PS. I just put the pictures in. Thought maybe they'd coax you

*Frueh called Giuliette Fanciulli's letters "pinkies," in light of the fact
that they were written on pink paper. Mutt is an imaginary character
in Frueh's cartoons. When Frueh wrote this letter, he was unaware
that his caricatures of American actors and actresses were on exhibit
at Alfred Stieglitz's 291 Gallery in New York. It wasn't until Giuliette
sent him a newspaper clipping the following week that he realized
that the exhibition had opened on November 20, 1912.*

Walter Gay to Matilda Travers, 1 March 1889
Letter, 4 pages, handwritten, illustrated
Walter Gay papers, 1870–1980

18 Rue d'Armaillé
March 1, 89

My dear Matilda

I have waited in vain for a letter from you today.

Every time the Facteur comes, I have met him with a beating
heart, only to be dissapointed.

If you only knew how I depend upon this letter from Nice.
It is the only respite I have, during the live long day, from my
troubles. I am unhappy the whole day until I get your letter, and
then everything is smiling.

I am so much a prisoner here, shut up in my studio, with
nothing but memories to live upon.

Even one day without hearing from you, is misery. Have I
said anything to offend you, in my wretched scrawls, or anything
which you haven't quite understood?

Really, you know me well enough now, to know that if I
have, it hasn't been intentional, the Lord knows.

Your letter of Feb 27 has just arrived. Pardon the above
complaints. It is all right again, and I am so happy! How far we
are apart though. You speak of my London letters still, & your
letter was written three days ago. All that I have written since
was not received at the time you mailed your letter.

There is no question about it, <u>we cannot be separated again</u>.
I couldnt bear it, & I don't believe you could. It is a terrible
trial, & for what use.

Just as I have won you, to have you torn away from me.

If you only knew how I want you, <u>my darling</u>, <u>my darling</u>!
You <u>will</u> know when we are together and I can prove it.

The telegram from your sister Susan was charming. I have
kept it, with the <u>very</u> precious things in the little pocket book
that belonged to my family. Mr Wm. Dana has just called to
congratulate me in person. I am to dine there, on Sunday, to tell
them all about it.

Many people think we would avoid trouble in the wedding
by going to London, but of that we can tell nothing until we
meet. I dare say the Minister would be able to do wonders for
us here.

I have got a copy of the French law of Marriage and Conflict of Laws therefrom by Edmond Kelly [New York: Baker, Voorhis, 1885]. It is complicated, but I dare say, the Minister could smooth it over.

Yours affectionately,
Walter
P.S. I am glad DeCourcy Forbes approves of me. I hardly know him, but I know his family.

Wm. Dana is painter William Parsons Winchester Dana (1833–1927); DeCourcy Forbes is Henry DeCourcy Forbes (1872–1880).

Xavier Gonzalez to Ethel Edwards, 28 November 1955
Letter, 3 pages, handwritten
Xavier Gonzalez papers, 1905–1970

Nov. 28–1955

Sweetheart:

There are exactly 6 hours difference. My watch says—Flew directly from N.Y. to Madrid couldn't land in Lisbon because of low clouds—Must be about two P.M. in Wellfleet now and my heart is lonesome for you. This hotel is really something, elegant—and the service!! Already I have to suits pressed and my shoes cleaned and the bed turned—all fine linen and silk—

I bathed and the towels are bigger than I am. Avelino came with all the family—They are more much wider than before but all sugar and nice feeling—The stockings were a great joy—

I am going to take a nap because I am sleepy—

I will supper tonight with Avelino y family near the hotel # The girl is teaching, one boy is a Doctor and the other studying pharmacy—

[hearts]

I told them all about you they think you are the most georgeous girl and etc etc—which is music to my ears, I love to hear people talk like this about my darling--------BUT I was mean I said you were slim as a papyrus and AN ARTIST.

All my love darling; I'll write tomorrow I'll call a boy to mail this right away.
Your Xavier, keep yourself away from drafts and cold winds—

Cynthia Hart, ca. 1958
Story, 1 page, handwritten, illustrated
Harold Paris papers, 1946–1982

Once upon at time there lived an artist; a man who painted beautiful pictures of landscape. He was very handsome, with blue-black and straight shiny hair. His nose was terribly long and elegant, like this.

[drawing of a nose]

One day he happened to meet a lovely young princess and fell in love with her and they lived happily ever after together in his studio.

Andrew Dasburg to Grace Mott Johnson, ca. 1907
Letter, 1 page, handwritten, illustrated
Andrew Dasburg and Grace Mott Johnson papers, 1854–1979

To a little(?) calf!!!
Rufus!! Rastus! Johnson!
Mine!!
Won't you be my
Valentine?

Yes!
No!
Which?

Grace Mott Johnson to Andrew Dasburg, 2 August 1908
Letter, 3 folios, 12 pages, handwritten
Andrew Dasburg and Grace Mott Johnson papers,
1854–1979

Columbus O. Aug. 2nd 1908
Sunday.

My dear Andrew;

Your letter of the 30th utd. [unable to deliver] which Mr.
Mark brought me soon after I mailed my short note to you, was
very interesting, if written under difficulties, and set me thinking
of many things.

A great deal has accumulated in my mind recently that I
should like to speak with you about in the hope that there might
be a fuller understanding between us. My surroundings are more
conducive to quiet and clear thinking than yours just now, and I
hope I can make use of the opportunity to note and consider
some things (for my own benefit as much as anything) in a way
that I shall not regret.

Forgive me if I repeat sometimes what I may have wearied
you with speaking before.

There seem to be reasons both for and against our mating;
and as one does not buy a farm or breed a horse without careful
consideration of caracter and antecedents, why should one
plunge headlong into something that may affect his own & others
happiness even more nearly?

I believe it does not seem so to you, but to me who never
thought it possible that I should marry one with whome I had not
been in close relation for many years—it appears rash at times.

I believe life is largely, if not wholly a game of chance, and I
have enough of the spirit of the gambler to feel that this adds
interest to every thing in it—my own work for example.

But this might give us pause before throwing the dice when
the stakes are heavy.

Two persons occupied as we expect to be in work that can
be carried on partly at home and under various conditions,
would seem to have exceptional opportunity to rear and be the
companions of there children somewhat as we desire.

And our labor being in branches of the same art, and our
interest in art and many other things mutual, we two seem to
have a firmer ground of friendship than many. And as we have

both hoped to live a real & natural life and not to die childless,
we are so far at one.

You have opened my eyes to much that is beautiful, and I
think this is the best I could wish to be able to do for the world
or anyone, and I believe what your work expresses will be a joy
and inspiration to me in the future. And you know that I
admire you for many things, some of which I have told you and
some that I will tell you, perhaps. But the greatest of all is that I
believe you to be sincere, that your life is single and open and
that I can confide in you.

You know better than I what you see in me that makes you
feel I can be your mate.

On the other hand we differ too much perhaps, to be even
compliments of each other.

And also should we not consider what we want and what
we can expect of each other instead of courting disappointment
by a vague idea that everything will adjust itself happily and that
we are agreed at bottom?

I hope I can live up to my conviction that each is responsible
to himself alone and has no claims upon the other. It seems to
me the only solid basis of respect and peace of mind in whatever
relation of life, between free and equal individuals.

You have often spoken of your fear that we may not satisfy
each other. There are so many ways in which it seems to me I
should fail to satisfy you that I wish you would reflect upon them
and tell me whether, when weighed in cold blood they should
not make you reconsider your choice. And tell me what they are.

On my side I will try to be quite frank and tell you of some
of the ways in which you may not fully satisfy me.

I grant I should like for [a] comrad and for the father of my
children one whose culture and education would make it possible
for him to give them what was my birth-right, in a way, and
which I feel I have gone back upon—Who could converse of
science and literature and fill up my want a little more than you.
For often, especially in the Fall of the year, I have so strong a
desire to bury myself in books & study that I should probably do
so at times if my reading were not so slow. I fear that recurrence
of my old hunger for table talk from my father and converse with
him in walks such as might have been.

And I wish that I had reason to feel sure that it was natural
to you to consider the individual first and the sex, race and
customs second without prejudice, in your fellowship & in
spontaneous thought.

What I have said of your appearance seems a small thing to trouble one, but you told me once you would not have me if I were a giantess, so pray pardon the allusion. (It is hard for me to write unambiguously to-day, and on revision nothing sounds as I mean it.)

The way in which the unfolding of the caracters of various people seems to surprise you and the slight degree in which your mind seems to take account of psychological subtilties, sometimes, was what led me to call you "kid" I think, and reminded me of Emerson's fine description of a boy. When you spoke of Miss Miller's having played ~~at~~ a part, so to speak, with you, it made me trembled lest I had done the same thing for I know how much ~~a part of me~~ it is in my nature to do so ~~the same thing~~ more or less unconsciously with any one I want to please. But I am sure I have been more ingenuous with you than with anybody, and had not the temptation of wanting to please.

I will not try to write you my autobiography (hope you will help me break the habit of giving chapters of my childhood ~~to people~~ as much as I am inclined) but I should like to speak of something which I never confessed to any one but Alfred, and to him only in a general way. I have mentioned how my imagination was always active. First it was in Arabia among visionary horses, later, stimulated by Scott etc. it went to sea and to war. From 1896 it was principally love, of course, for years—developing into the lives of individuals which I conjured up more real and vivid than actual things, into which I wove all my passions and ideals of life etc.

In my lonlyness and spirit of rebellion and desire for action & life, common to all youth, but intensified to a white heat of conflicting emotions by the peculiar circumstances of my lot and my tenacious affection and hold upon things bygone, this imagination was like opium to me.

The boys used to notice my absentmindedness, but no one knew how absent I was. I hate to think of such waste of time, for it is deadening to the brain & grew upon me until I began to fight the habit as a man will fight the demon alchohol.

I felt what I needed was action and a change of life, and it was partly this that determined my breaking away from home.

I suppose it accounts largely for my slowness and stupidity in some things and my liability to say that four times eight are twelve—my brain has been drugged.

It seems a good while ago now that I was wrestling with this & I do not think it likely to recurr, unless in case of illness or long & solitary inaction.

Well, I am glad that reality can seem real again.

I wish some times you were here to speak German with Mr. Mark and see this family which is more like my home in many ways than I supposed anything could be.

When I consider it, one of the hapy homes of the land, with fine family spirit, good manners, controll of temper, order, industry and cleanliness, I sometimes wonder whether ours would be in any way its equal.

And when I think how it is maintained by the labor of the father in his poultry houses from 4 A.M. to 8 P.M. (when we all go to bed) and the labor of the mother nearly all that time in the house, there being only two children and everything done in the most laborsaving & simplest way, I wonder how that home which you said in the plasteline restaurant you would demand, is to be realized. For housework does not do itself. Even if there is means to hire servants the cry that they are very hard to get and most inferior and unreliable then, is going up to heaven all over the land from rich & poor alike. besides they require constant supervision, and though they (are supposed to) do the ~~do the~~ dirty work, the saving in time is not so great after all.

And to me their presence takes away much of the home likeness of a home. Still one can try. A childhood in a nest in the east and a youth more on the frontier at least a taste of ~~taste of~~ the West and larger things ~~and chance for~~ [illegible word] was among my dreams, indeed.

And daughters who would give their brothers no cause to think, as you did at the batteries, that they could not fire canon as well as a man. But I suppose this is unnatural and I think I can appreciate altogether different types—even that delicate (pink & yellow?) flower variety.

I am weary and will stop here. See No. 2.

I had thought myself of your sending a sketch by mail as you suggested. Should like to see one very much. I hope we ~~shall~~ shall never regret. I know what ever else I may say that your love is gold to me. G. M. Johnson

P.S. Remember me to your family.

Frida Kahlo to Nickolas Muray, 27 February 1939
Letter, 8 pages, handwritten
Nickolas Muray papers, 1911–1978

Paris Feb. 27. 1939.

My adorable Nick—
This morning after so many days of waiting—your letter arrived.
I felt so happy that before starting to read it I began to wep. My
child, I really shouldn't complain about any thing that happens
to me in life, as long as you love me and I love you. It is so real
and beautiful, that makes me forget all pains and troubles, makes
me forget even distance. Your words made me feel so close to
you that I can feel near me your eyes—your hands—your lips. I
can hear your voice and your laugh. That laugh so clean and
honest that only you have. I am just counting the days to go
back. A month more! And we will be together again.

Darling, I made a terrible mistake. I was sure your birthday
was the 16th of January. If I knew it was the 16th of February I
would never send that cable that caused you unhappiness and
trouble. Please forgive me.

Five days ago I left the hospital, I am feeling much better
and I hope I will be entirely well in a few days. I didn't go back
to the damn hotel because I couldn't stay all alone. Mary
Reynolds a marvelous american woman who lives with Marcel
Duchamp invited me to stay at her house and I accepted gladly
because she is really a nice person and doesn't have anything to
do with the stinking "artists" of the group of Breton. She is very
kind to me and takes care of me wonderfully. I feel rather weak
after so many days of fever because the damn infection of col-
libacili makes you feel rotten. The doctor tells me I must of
eaten something which wasn't well cleaned (salad or raw fruits)
I bet you my boots, that in Breton's house was where I got the
lousy collibacili. You don't have any idea the dirt those people
live in, and the kind of food they eat. Its something incredible. I
never seen anything like it before in my damn life. For a reason
that I ignore, the infection went from the intestines to the blader
and the kidneys, so for two days I couldn't make pipi and I felt
like if I were going to explode any minute. Fortunately every
thing its ok now, and the only thing I must do is to rest and to
have a special diet. I am sending you here some of the reports
from the hospital. I want you to be so sweet to give them to
Mary Sklar and she will show them to David Glusker, so he can
have an idea of what is the matter and send me indications of

what I should eat. (Tell her please that for the three last days the
urine tests shown that it is acid and before it was alkaline. The
fever desapeared completely. I still have pain when I make pipi
and a slight inflamation on the blader, I feel tired all the time
(specially on the back)

Thank you my love, for making me this favor, and tell
Mary that I miss her a lot and that I love her.

The question of the exibition finally its settled. Marcel
Duchamp has help me a lot and he is the only one among this
rotten people who is a real guy. The show will open the 10th of
March in a gallery called "Pierre Colle" They say its one of the
best here. That guy Colle is the dealer of Dalí and some other big
shots of the surrealism. It will last two weeks—but I already
made arrangements to take out my paintings the 23th in order to
have time to packed them and take them with me on the 25th.
The catalogues are already in the printing shop, so it seems that
every thing is going on alright. I wanted to leave on the "Isle de
France" the 8th of March, but I cable Diego and he wants me to
wait till my things are shown, because he doesn't trust any of this
guys to ship them back. He is right in a way because after all I
came here only for the damn exibition and would be stupid to
leave two days before it opens. Don't you think so? In any case,
I don't care if the show will be a successful one or not. I am sick
and tired of the whole affair here in Paris, and I decided that the
same thing would be in London. So I am not going to make any
exibit in London. People in general are scared to death of the war
and all the exibitions have been a failure, because the rich bitches
don't want to buy anything. So what is the use of making any
effort to go to London to waste time only?

My darling, I must tell you, that you are a bad boy. Why
did you send me that check of 400 bucks? Your friend "Smith"
is an imaginary one—very sweet indeed, but tell him, that I will
keep his check untouched untill I come back to New York, and
there we will talk things over. My Nick, you are the sweetest
person I ever known. But listen darling, I don't realy need that
money now. I got some from Mexico, and I am a real rich bitch,
you know? I have enough to stay here a month more. I have my
return ticket. Every thing is under controll, so realy, my love, it
is not fair that you should spend any thing extra. You have planty
of troubles already to cause you a new one. I have money even
to go to the "thieves market" and buy lots of junk which is one
of the things I like the best. I don't have to buy dresses or stuff
like that because being a "tehuana" I don't even wear pants, nor
stockings either. The only things I bought here were two old

fashion dolls, very beautiful ones. One is blond with blue eyes, the most wonderful eyes you can imagine. She is dressed as a bride. Her dress was full of dust and dirt, but I washed it and now it looks much better. Her head is not very well adjusted to her body because the elastic which holds it, is already very old, but you and me will fix it in New York. The other one is less beautiful, but very charming. Has blond hair and very black eyes, I haven't wash her dress yet and is dirty as hell. She only have one shoe. The other one she lost it in the market. Both are lovely, even with their heads a little bit loose. Perhaps that it is which gives them so much tenderness and charm. For years I wanted to have a doll like that, because somebody broke one that I had when I was a child, and I couldn't find it again. So I am very happy having two now. I have a little bed in Mexico, which will be marvelous for the biger one. Think of two nice hungarian names to baptize them. The two of them cost me about two dollars and a half. So you can see my darling, that my expenses are not very important. I don't have to pay hotel because Mary Reynolds doesn't alow me to go back to the Hotel all by myself. The hospital is already payed. So I don't think I will need very much money to live here. Any way, you cannot imagine how much I appreciate your desire of helping me. I have not words to tell you what joy it gives me to think that you were willing to make me happy and to know how good hearted and adorable you are. — My lover, my sweetest, mi Nick—mi vida—mi niño, te adoro.

I got thiner with the illness, so when I will be with you, you will only blow, and….up she goes! the five floors of the La Salle Hotel. Listen Kid, do you touch every day the fire "whachumaycallit" which hangs on the corridor of our staircase? Don't forget to do it every day. Don't forget either to sleep on your tiny little cushion, because I love it. Don't kiss any body else while reading the signs and names on the streets. Don't take any body else for a ride to our Central Park. It belongs only to Nick and Xochitl—Don't kiss any body on the couch in your ofice. Only Blanche Heys can give you masage on your neck. You can only kiss as much as you want, Mam. Don't make love with any body, if you can help it. Only if you find a real F.W. But don't love her. Play with your electric train once in a while if you don't come home very tired. How is Joe Jinks? How is the man who massages you twice a week? I hate him a little, because he took you away from me many hours. Have you fence a lot? How is Georgio?

Why do you say that your tripp to Hollywood was only half succesful? Tell me all about it. My darling, don't work so hard if you can help it. Because you get tired on your neck and on your back. Tell Mam to take care of yourself and to make you rest when you feel tired. Tell her that I am much more in love with you, that you are my darling and my lover, and that while I am away she must love you more than ever to make you happy.

Does your neck bothers you very much? I am sending you here millions of kisses for your beautiful neck to make it feel better. All my tenderness and all my caresses to your body, from your head to your feet. Every inch of it I kiss from the distance.

Play very often Maxine Sullivan's disc on the gramophone. I will be there with you listening to her voice. I can see you lying on the blue couch, with your white cape, I see you shooting at the sculpture near the fireplace. I see clearly, the spring jumping on the air, and I can hear your laugh—just like a child's laugh, when you got it right. Oh my darling Nick, I adore you so much. I need you so, that my heart hurts.

I imagine Blanche will be here the first week of March. I will be so happy to see her because she is a real person, sweet and sincere, and she is to me like a part of yourself.

How are Aria and Lea? Please give my love to them. Also give my love, to the Kid Ruzz tell him that he is a swell guy.

My darling, do you need anything from Paris? Please tell me, I will be so happy to get you anything you may need.

If Eugenia phones you, please tell her that I lost her adress and that is why I didnt write. How is that wench?

If you see Rosemary give her lots of kisses. She is o.k. To Mary Sklar lots of love. I miss her very much.

To you, my loveliest Nick, all my heart, blood and all my being. I adore you.

Frida
The photographs you sent finaly arrived.

Breton is André Breton, French surrealist. Mary Sklar and Blanche Heys [Hays] were mutual friends of Muray and Kahlo. David Glusker was a physician who advised and treated Kahlo. Kahlo referred to herself as Xóchitl, which means "flower" or "delicate thing" in Náhuatl, the language of the Aztecs. Mam is Marion Meredith, Muray's studio manager. Ruzz is Ruzzy Green, who also worked with Muray. Joe Jinks is a popular comic strip. Aria is Arija, Muray's daughter. Lea is Leja Gorska, Muray's second wife and Arija's mother. It is not known who underlined the words in this letter.

Rockwell Kent to Frances Lee [March 1926]
Letter and sample monograms, 2 pages, handwritten
Rockwell Kent papers, ca. 1840–1993

Flk

Frances! I am so lonely I can hardly bear it. As one needs happiness so have I needed to love; that is the deepest need of the human spirit. And as I love you utterly, so have you now become the whole world of my spirit. It is beside and beyond anything that you can ever do for me; it lies in what you are, dear love—to me so infinitely lovely that to be near you, to see you, hear you, touch you, is now the only happiness, the only life, I know. How long these hours are alone!

Yet is good for me to know the measure of my love and need, that I may at last be brought to so govern myself as never to lose the love and trust that you have given me. Dear Frances, let us make and keep our love more beautiful than any love has ever been before.

Forever, dearest one,
Thy
Rockwell.

Lee Krasner to Jackson Pollock [21 July 1956]
Letter, 1 page, handwritten
Jackson Pollock and Lee Krasner papers, ca. 1905–1984

Sat—
Dear Jackson—
I'm staying at the Hôtel Quai Voltaire, Quai Voltaire Paris, until Sat the 28 then going to the South of France to visit with the Gimpel's & I hope to get to Venice about the 2nd early part of August—It all seems like a dream—The Jenkins, Paul & Esther were very kind; in fact I don't think I'd have had a chance without them. Thursday nite ended up in a Latin quater dive, with Betty Parsons, David, who works at Sindney's Helen Frankenthaler, The Jenkins, Sidney Giest & I don't remember who else, all dancing like mad—Went to the flea market with John Graham yesterday—saw all the left-bank galleries, met Druin and several other dealers (Tapie, Stadler etc). I am going to do the right bank galleries next week—& entered the Louvre which is just

on across the Seine outside my balcony which opens on it—About the "Louvre" I can say anything—It is over whelming—beyond belief—I miss you & wish you were shari sharing this with me—The roses were the most beautiful deep red—kiss Gyp & Ahab for me—It would be wonderful to get a note from you. Love Lee—
The painting hear is unbelievably bad
(How are you Jackson?)

The Gimpels are possibly art dealer brothers Charles and Peter Gimpel, who founded Gimpel Fils in London in 1946. The Jenkins refers to painter Paul Jenkins and his wife, Esther. Betty Parsons (1900–1982) was Pollock's first dealer in the late 1940s and early 1950s. Sindney's is most likely the Sidney Janis Gallery in New York. Gist is Sidney Geist (1914–2005), sculptor, teacher, and art writer. Druin is art dealer René Drouin. Tapié is artist and art critic Michel Tapié (1909–1987). Stadler is art dealer Rudolphe Stadler. Gyp and Ahab are Pollock and Krasner's dogs.

Krasner stayed with Paul and Esther Jenkins in Paris. That is where Clement Greenberg reached her by telephone to tell her that Pollock had died on August 11, 1956.

Joan Mitchell to Michael Goldberg [1951]
Letter, 4 pages, handwritten
Michael Goldberg papers, 1942—1981
All works by Joan Mitchell © The Estate of Joan Mitchell

Wednesday

Hey beautiful,

Just got your letter—"oh for just a chance to love you—could I love you"—can't figure out whether I like the radio on or off—Je t'aime—God you mean a lot to me—it's never been like this before in my life. I cleaned the studio—made the bed—I like it so much—the white palette things are sort of in the middle of the room—I can't paint against the wall like you had them—I'm using the paint off your palette—I feel so close to you—I'm still working on that green & black thing—so slow and it's so big—started a couple more little—nothing much—I keep thinking we could live here together, but I mustn't think at all. Drank a bottle of bourbon with [Philip] Guston last night—

talked about painting—we don't agree at all, but he was nice—he doesn't like [Arshile] Gorky or [Willem] de Kooning—likes Mondrian & more intellectual or classic or whatever you call them things. I would like to paint a million black lines all crossing like [Max] Beckmann—to hell with classicism—this is only momentary—beautiful—agony and not in any garden. The only thing I look forward to is writing you and then I can't write anything. I wrote you a letter yesterday to UE5 instead of 7—I hope you get it—I'm sorry—I don't know what happened. Micheal makes me strong—makes you strong—your mother & father are seeing Lubart tomorrow at 2:45—I'll meet them afterwards—do you remember running up Madison—we still are running to meet each other darling—and it can't be forever—it would be so wonderful to see you. I can't leave you money for a little while—a week or so—then I will. I'm drinking the beer you left on the windowsill—& I'm kissing you—this I do all the time. How long will it be?? I can understand you not being able to draw—it sounds impossible—I sometimes wonder how in hell you painted three weeks ago—it's over that now—I counted weeks last fall and we were laughing. I hate Tuesdays now and the weeks start & end with it—I sat in the park this morning & you were with me and we talked about things that we had never mentioned & much we had and I held your hand—could we make it over again in a different way? There's a woman across the way who's always looking out the window. I'm sick of looking at her. I put all four lights over the curtains and make coffee often. It's so quiet and stays light so long & what are you thinking—oh Mike I wish I could help you—Parsons came—very enthusiastic—said she was full but would talk to Dorothy Miller etc. She was nice. I like the New Gallery anyway—what do you think of all this—should I have a show there—without you, its impossible—Quiero morir [I want to die]—but I won't—do you realize [unreadable] that I'll see you again—a light in the darkness—and it can't be so very much longer—but I will see you & talk to you—what a beautiful thing. Micheal I'll write you more often—it's just a little easier to do it now—how do you spell what the pig said?—I will sleep now—maybe—it used to be so easy—and the cot is filled with you—save your drawing ideas. Someday we'll line a room with canvas & you'll have an enormous brush and lots of back and white and cad. red deep & you'll paint them all at once and I'll have my arms around you. Goodnight—Je t'aime.

J.

"Oh for just a chance to love you—could I love you" is from the song "Would I Love You," made popular by Frank Sinatra. UE5 was Goldberg's address at the Rockland State Hospital. According to Joan Mitchell's biographer, Patricia Albers, Lubart was one of Michael Goldberg's psychiatrists. The "white palette things" are tables on wheels that apparently belonged to Goldberg. The phrase "how do you spell what the pig said" may refer to Bessie Smith's song "Gimme a Pigfoot (And a Bottle of Beer)," which Goldberg introduced to Mitchell, and for a time it was their song. Parsons is art dealer Betty Parsons (1900–1982). Dorothy Miller (1904–2003) was a curator at the Museum of Modern Art. Mitchell had a one-person exhibition at the New Gallery in New York City, from January 14 to February 2, 1952.

Elliot Orr to Elizabeth Orr, ca. 1936
Letter, 3 pages, handwritten
Elliot Orr papers, 1910–1984

Monday
Apres-midi

P.S. your information concerning Marchall much appreciated. Will await all further news. Will look for a lamp as you suggest. E.

Dearest Piepet:

Your noble book of Sunday arrived on a freight car to this remote and extremely wet Waquoit [Massachusetts]. Now after bringing it down in the rumble seat and opening it up I wish to report its contents satisfactory, pleasant and entertaining. I do however reserve any praise or final comment on the content of lower page 7 and 8 of said book. Namely, that part which goes into some sort of esthetics (?) (Damn it why did you take the dictionary) To be more specific you ask my advice in certain matters of an Artists point of view Etc. I am not sure that you make yourself clear however if I interpret your statements at all and am foolish enough to answere questions on esthetics (even when I'm not sure what is asked) then count me for the fool that I am about to be.

1. An Artist might well feel that death was ~~was~~ the end of Beauty <u>for him</u>, that is, the beauty of the earth and of life. But I can hardly imagine any one believing

that he alone ~~were~~ was the perpetrator of Beauty
and he alone could make that fair goddess smile.

2. I would not say that the Artist who paints his soul was
no good. Rather I should say he was no better than the
greatness of his soul.

3. "Bitterness" is a youth's disease. It presupposes a
certain expectancy and hope. Candide's philosopher
was ~~right~~ wisdom himself when from the burning
building he weakly said in his misery, "It is the best of
all possible worlds."

4. The artist I believe is not trying to elevate any one.
That may or may not be a result as in the case of the
stoic I should say his chances are quite slim. I have not
attended the Royal Academy for nothing. Nor do I
think the artist is always poking around in the realm of
uncertainties puzzling over "what is what." He may to
be sure endeavor to lift the veil a little, but sooner or
later he accepts the mystery. It is not necessary to
understand the riddle of the universe it is enough to
know that it exists. To me the Artist does something
quite simple he sings songs. Some songs are sweet like
the bird high up in the sky. Some songs are sad like the
death of a child. While others are terrifying like the
shriek of the hurricane. The artist loves the storm, but
he loves the star lit sky too. To love is to understand a
little better. You ask, "Must the artist not remember
that he is a mortal too? If only he could forget it!

I stood in the open fields and beheld the face of God.
Radient with the miracle of autumn. Gold pure gold, and red so
rich in hue that I became silent in my delight.

Looking long at this great mystery of beauty I became
troubled and my whole being longed for something that lies
outside our vision and our life.

Well my sweetheart I am so glad you were not here yesterday
or to-day. Why? Because the "eternal rain, cold, maledict,"
poured down upon Waquoit and this very hour it has ceased.
Hail! to the Sun and the blue sea. I have burned up all my wood
taking the shivers out of the rabbit dogs hind legs and my own two.

In regards to your new position Tred lightly my love until
we see just what is the best thing to do for the winter.

To-morrow I will have the Bank news and will send it along
to you. Now there is not much more to say. I am working very
hard and my health is excellent. I have stopped smoking altogether.
I will remember to let you know if anything goes badly with me—
as you request. I send you all my love and kiss you lovingly.

Elliot

*The salutation "Piepet," may be "Pipette," as Elizabeth Orr was
a chemist and worked in a medical lab. "No. 3" may refer to
Orr overcoming a recent tragedy: In February 1934, his studio at
48 West Twelfth Street in New York City was destroyed in a fire. He
lost some thirty paintings and hundreds of drawings. The phrase "the
best of all possible worlds" was coined by the German philosopher
Gottfried Leibniz in 1710, and satirized by Voltaire in his novel*
Candide *(1759).*

Waldo Peirce to Sally Davis, ca. 1943
Poem, 2 pages, typewritten, illustrated
Waldo Peirce letters, 1943

Ballad of the Sensitive M.P. and the Sleeping Bathtub Venus

Now listen all ye Waccodils
Auxiliaries and Loots
Aye them that bawl their betters out
And them that lick their boots

To a most woeful ballad
Of a sensitive M.P.
And a shlapin Bathin beyooty
All in Hindquarters 43

This super-sensitive M.P.
On his diurnal round
Felt that he was unbeloved
A feeling mostly sound

Yet beneath that martian tunic
And a countenance like clam
There beat a heart as tender
As one of unborn lamb

Among those boyless waccodils
Who felt they were in prison
No soul among those souls forlorn
Was lonesomer than hisn

Onr morning just at daybreak
He wound through their bleak quarters
"My God" he cried "Wots this I hear?
It sounds like running waters"

Like a sudden sweet spring torrent
It shook his reverie
Trancelike his feet had led him
To Hindquarters 43

In vain he thumbed his manual
And read from to A to Z
For one word on Spring Torrents
In a gals' dormitoree

And then the waters silent were
And he stood before a door
Marked " FOR 8 WAACS ONLY "
Jest that. .and nothing more

The supersensitive M.P.
Hearing no further sound
Felt his heart leap as he thought
My God they may be drowned

So he boldly pushed the door in
Did that sensitive M.P.
And rushed up to the bath tub
And then wot did he see?

There in those tranquil waters
A'floatin by her side
A dwindlin piece of Ivory Soap
And a book.. "Who Axed the Bride?"

In regulation posture
As modest as could be
Like that famous Venus
Known as La Medici

Unto the optic survey
Of thatM.P. was displayed
Without guile or malice
Our sleeping Adelaide

Who in her slumber muttered
"I leave the door ajar
But never see that dear M.P.
I've loved so from afar"

Tho by the utmost discipline
Revamped and fortified
At them kind words the sensitive
M P. dropt down and died

Just at the very moment
The M.P.hit the floor
Another waacian vestal
Came rushing in thedoor

It was our flaming Jessie
Full fifteen minutes late
Half out of her pyjamers
The last one of the 8

"I knew I'd find you sleeping
I forgot to wind the clock"
And then she saw the poor M.P.
"Dear me he's had a shock

I remember I remember
One lesson of First Aid
Always treat 'em lying down
Wake up dear Adelaide!"

With a fistful of cold water
She roused the sleeping Venus
"Wot about some artificial
Resperaysh between us?"

Waldo Peirce to Sally Davis [1943]
Poem, 1 page, handwritten, illustrated
Waldo Peirce letters, 1943

I LOVE MRS BUBBY
HER BREASTS ARE SO FIRM
IF I DONT MEET HER HUBBY
THEY'LL DO ME NO HARM

THO HER OFFSPING SHE LEFT
IN THE LONE STATE OF TEXAS
SHE BROUGHT BOTH HER BUBBIES
AND A WAAC SOLAR PLEXUS

I LOVE MOTHER HUBBY
HER BUZOOM IS SO HIGH
LIKE TWO LITTLE BLIMPS
AFLOAT IN THE SKY

[refers to illustration]
BROOMS RIGHT!
MOPS LEFT!

Gio Ponti to Esther McCoy, n.d.
Letter, 1 page, handwritten, illustrated
Esther McCoy papers, 1896–1989

Dear Esther, our dear, this is my last drawing letter for see you, we love, love love, love, love, love, love, love, love you

Giulia & Gio

Gio Ponti to Esther McCoy [December 1976]
Letter, 1 page, handwritten, illustrated
Esther McCoy papers, 1896–1989

Alla cara Esther
con affettuosi pensieri
in questo Natale che
per me è il primo
senza Giulia, ahimé!
Gio

To beloved Esther
with affectionate thoughts
on this Christmas that
for me will be the first
without Giulia, alas!
Gio

Giulia was Gio Ponti's wife. She died in March 1975.

Eero Saarinen to Aline Saarinen [10–11 April 1953]
Letter, 10 pages, handwritten, illustrated
Aline and Eero Saarinen papers, 1857–1972

ALINE

This will not be written with scalpel like objectivity it is just going to be small talke ----- and than the phone rang and I heard your very nice voice and also all the very nice things you said --- of wich the very nicest was "I love you so much darling" ---- while I was drawing your letter on the plane I had a fellow next to me of they type that just gets on planes to strike up conversations – he wanted to know what I was doing because he was curious which apparently was sufficient excuse in his mind to ask – I told him it was a dream --- and continue—the thing I liked most about the monument was that it was a beautiful result of you & I being close together---the funny thing about it is that it proves your point in your article soo much – that I translate everything into architecture ---- you could now say "He eaven sees his closest friends as stone and concret" –or "he looks at this reporters and" ---- and so on—

Now – just talk about things the office the Drake "Bible School" It is a tiny little class room building with a tiny chapel – near it is to be a bigger chapel – I think it is going to be O.K. Now. – it is located next to the science and pharmacy building we did and not far from dormitories now under construction – the whole thing really becomes a campus & when these are built Drake will really have quite a good group of new buildings. – if plans are accepted (Wedsday) than it will look like this.

[Captions on drawing, page II]

Dormitories

Mall

Future chapel

Lake in ravine with bridges across to stimulate romanticism in girls

Future mall

Bible school

Wall because ground slopes

Existing

Court I think will be nice.

Main future chapel – we may get in trouble on this one later combining circle and rectangle may be degenerate.

Central table (altar) with light above wall of slabs of brick with slits (6") between.

Very simple class room building with all columns disengaged from walls.
This drawings & design stinks compared to → but this is only small talke.

All interior walls off columns (Kump did this in school once.)

Page III

Next – a site plan we are doing for U. of M. – it is a triangular piece of ground and everything conspires to making triangular lots possible – Jay Barr invented this one and I like it very well.

I can't remember how it goes but I think it would be fun. [caption for small triangular sketch.]

Next problem – Milwaukee Cultural Center – I have been scared to look at it for the last week because my mind has been so filled up but to-morrow at 2 P.M. I am going into it – I think our part now is good – I don't think you saw it. – It consists of a veterans building + art museum + theater for 3000 – the site is magnificent but has peculiar problems too long to explain. – if art museum goes ahead it will be very peculiar – Vatican is entered from below – this will be entered from above

[Captions on drawing]

City

RR Tracks

Existing

Express Parkway

Lake Michigan

Veterans Bldg on stilts – enter from city under it decend to sculpture court – enter museum galleries below court – ~~sculpture court wil~~ museum court will be mingling area for all activities – vet building to go ahead only until they collect more money

Page IV

Styling Auditorium is an other one I am scared to look at but will have to Sunday 11 A.M. – really get into it! –

Columbus Bank – I am going thru it carefully now and having terrible trouble with stairway ~~whie~~ trouble stems from a bit of confused thinking in the beginning and when that is inherant there is no end of trouble that one may never get completely logical.

M.I.T. – Working with Bruce & Joe on revisions ~~her~~ to cut down cost. 10 A.M. Sat.

MIT Chapel – Bruce & I have to start on a new version of iron works above – we intend to put lights there are well as the bell – same as what Aalto did over dining – it will make people conscious when chapel is in use – will also remedy objection of starkness – I think it will be better this I have to get to SOON – Monday or Tuesday

Michigan (U of M) is way behind will have to start soon on it including design of large music school (4,000,000)

<u>Stevens Chapel</u> – should look into soon to see what can be done to reduce cost – I don't like this job but we have to do it.

<u>Motorola</u> intends to build new laboratory (4,000,000) in Chicago ~~but~~ and is considering us & others – I am supposed to go to Chicago the 22^nd to appear & "sell" myself but job is not interesting and to-morrow I will tell them we don't want to be considered – that always impresses people!
--------------Anyway this is roughly what goes on in my mind about work and I just wanted to tell you about it but I will stop talking about work now because I get all nervous thinking of all the things I should concentrate on – ~~thank~~ I am glad that I decided not to go to New Haven - - - - now from all this talke about work I shall change the subject so much that I need to start an other page -----

Page V

My mind wanders to the beautiful complete time we had in Boston. It wanders very often – and it is very hard for me to believe that it is all true and that it exists in two minds – a nice thing you said in one letter and also to-nite on the phone – was - "long term" – something – this is a thing I hope for also – I think this way → she seems so very nice – – but remember Eero you have not known her very long – – but the more I know of her and the more time I spend with her the more I just like to be with her --- but remember Eero if she is as nice as all that it is much much better to learn to really know her slowly – slowly --- also remember Eero you have been a very confused little boy this last year your confusion is not over yet time is what you need right now – you really should clear things up and get a perspective before your get overenthusiastic – but when I say that she is nice I really mean it an if I broke it up in its component parts I would say ---- I like her spirit & enthusiasm, I like that combined with the clear sharp brain. I like her looks-eyes-smile-figure. Humor, energy, generosity – etc. and as a proof that I love her I know how I feel with her and I also know how my mind wanders to her – and than there are the very nice dreams --- yes yes Eero I agree with all that but hold your feelings and thoughts back at this time—that is much better in the long run for so many reason – – to learn really to know a person is somewhat like digging up a very fine treasure.

Page VI

You go about it (with scalpel like objectivity) carefully slowly and lovingly --- you treasure every part you find and you weigh carefully what parts are not there --- gradually than the whole person becomes a picture before you --- that is the very nicest way of knowing a person -- and you have to remember Eero that you are very slow in really knowing people --- yes I know but I think I have seen enough of this treasure to have an overall picture of this wonderful girl but I will admit that the finer the treasure seems the slower one should proceed, but you mentioned that there were <u>many</u> reason – yes Eero the thing I mentioned before you became very enthusiastic and very much in love in Europe—that creates many reasons why you should think very slowly—that has created certain repercussions at home which have to be thought out. They can only be thought out slowly— are you sure that you have thought thru everything in Europe – you think so now but give that also a little time. – – and besides Eero are you not talking to God damn much right now – I don't know – Perhaps. – Eero I like that dream you had the one about the round chapels and the ~~one you~~ temporary one you and A. where going to dig foundations for---it expressed the possibility of temporary but it also clearly said that one never knows one may strike rock – and than one could build a cathedral on the same footings

Page VII

Now for instance can I tell her that I really love her from the bottom of my heart – yes Eero that you can do because you really seem to do that.

LOVE
EERO

Friday nite, 1 A.M. [drawing of a heart]

[April 11]

Sat. nite 9:30 – Eero the cencor held up the letter of last nite until now to read it because it dealt with rather delicate things – he decided that it was OK to send if Aline reads it and rememberes with every word that I love you very very much – I don't know exactly how I have come to love you so much considering the very stormy period I have just come out of – I guess that is what it all dealt with————your letter arrived the one including bath tub poetry – I received it in a meeting and it was very difficult to wait thru the whole meeting to read it. – It was a very very beautiful warm – open arms letter—it expressed above all a yearning to expand our togetherness and also an eagerness to convery to me your life – that is why I loved it. —Darling I am terribly eager to just talke about you and my witch doctor to whom I have planned to say many many things travels so much as I do & therefore we never get together and I really look foreward to seeing him.——Merl Armitage (Look Art Director) was here for dinner with last world in new wife a French girl who seemed very nice. – He is an old friend from the war days. – Do you know him – he is very loud and opinionated but has a good heart.

I am looking foreward so much to coming east – seeing you – we could figure it out many ways – would you have a car? - I could easily rent one but it won't be a convertible – we could perhaps start driving Friday P. M. and stay somewhere and than see Bertoias things and than drive on – I once drive ~~th~~ thru that part of the country with George Nelson – years ago – the barns are very beautiful – I think.

Or at least I though the best in American aboriginal or unconscious architecture – we can also ~~do~~ figure it out many other ways the main thing is that we spend as much time as possible together – darling – I love you.

E.

P.S. If your son will be away it might be very much nicer not to drive away until Sat. AM because it would be wonderful to be with you in your own bed --- I would love that.

P.S. Now I have to stop because I have to read your letter.

P.P.S.

Darling

I don't really like this letter – I would like to write you a much finer one – but I don't know how – yours is much finer – it is absolutely marvelous.

There are so many things that you said that I would like to turn around and tell you also – inward worlds – outward worlds – darling – I love you.

E.

In 1945, Saarinen, Swanson, and Saarinen (the architectural firm headed by Eero's father, Eliel Saarinen, and Robert Swanson) prepared a master plan for Drake University in Des Moines, Iowa, designing a pair of buildings for the departments of science and pharmacy, as well as a women's dormitory complex. For more than a decade, Eero further developed the campus plan, designing a Bible school and prayer chapel, and another women's dormitory. Other architectural projects he mentions are his master plan for the University of Michigan, Ann Arbor, 1954; Milwaukee County War Memorial (1953–1957); the chapel at Stephens College, Columbia, Missouri (with Eliel Saarinen), 1947; Styling Auditorium at the General Motors Technical Center, Warren, Michigan (1948–1956); Irwin Union Bank and Trust, Columbus, Ohio (1952–1955); Kresge Auditorium and Chapel at the Massachusetts Institute of Technology, Cambridge, Massachusetts (1953–1955). Kump is architect Ernest J. Kump, Jr. (1911–1999). Jay Barr was a draftsman for Eero Saarinen and Associates. Merle Armitage (1893–1975) was the art director for Look *magazine. "Bertoias things" are objects by sculptor and designer Harry Bertoia (1915–1978). George Nelson (1908–1986) is also a designer.*

Italo Scanga to Dale Chihuly, 19 September 1997
Facsimile transmission, 1 page, handwritten, illustrated
Italo Scanga papers, ca. 1940–2001

Sept 19, 1997

Brother Dale.

in <u>Sept 20, 1941</u> I was 9 and 4 months old. it was during the
war, and hunger was running ~~rampid~~ rampid, but even then
1941 wasn't bad, like Sept 20, 1944, that was the worst but look
what happen to us. What a success my brother has become as an
artist and human, and ~~was~~ what a good son to Viola and a
brother to me. I know you don't like birthday. I think they are
silly, but some people take them serious. Best Regards
and much Love

Brother
Italo

everyone from Here sends
their love
especially <u>Su Mei</u> [Italo's wife]

Joseph Lindon Smith to Corinna Haven Putnam, 26 June 1899
Letter, 3 pages, handwritten
Joseph Lindon Smith and Smith family papers, 1647–1965

Monday night—26th June

My own sweet darling girl,

How I want to kiss you dear—how I want to feel you, warm
and sweet and loving in my arms—dear Carina—dear Corinna.
I love you—Oh I love you.
I can hear the sea, breaking gently against the rocky coast,
always a delicious song to go to sleep ~~with~~ to, but now—the sea
says words to me my darling, which it never did before – it says
things about you, and love, and our happy life to come—and I
feel you with me in spirit and I shall presently go to sleep, and
we shall meet in our dreams. Oh my love, my darling love.

The sea also tells me of the other lands, whose shores it
kisses in these beautiful Summer nights—of Italy, of Greece, and
lands of Poetry and Fable and it invites me out on its moonlit
bosom—to seek those lovely places and you—you Corinna—
sweet brown eyed girl you are in the fairie boat, which waits out
there to take me, and go we shall dear, and I shall do my best to
make your life the happiest you ever dreamed of. We shall see all
the Old World's treasures, both of Nature and Art, and my arms
will encircle you darling, and—well! it is all too much to write
of, but we shall be happy beyond all <u>words of expression</u>.
Now it's morning and I'm lying here in bed and you are in
my waking thoughts dearest, as much as last night. The sun streams
in at the open window—and like the quiet, low murmuring sea
last night, and the moonlight it makes me glad to be alive, and
makes me think of you, which is the dearest picture I shall ever
look upon.
I can see you lying in your bed, your pretty eyes shut—you
ca'nt be awake at this early hour. —when you wake up, it will be
because I kneel at your bedside and whisper in your ear, "love
love, while my arms steal around you—that's what wakes you
darling these happy days, is'nt it? —your old faithful and loving
Joe kissing you and telling you another day has come. I send
with this, a letter I have written to your Father which, if you
approve—you will send to him with yours won't you?—and I shall
now write to the three sisters and claim their affection, and tell
them of my love for you—will you send me their address please.
I shall go up to Dublin on Clara May's wedding day—
Thursday—and you must come with me darling. I will write to
Father to leave a boat over under the trees on the northern shore
and I will row you across to their loving arms, as they wait on
the ~~little~~ point for us—then we will walk up the hill through the
woods, and I shall kiss you when we reach a certain old leaning
tree—where you and I often stood—and loved each other in
those glad Autumn days, no so long ago.
Does this plan appeal to you my sweet pretty girl? or can
you suggest a better one?
Now I must get up, this morning we are to have some tennis
and luncheon at the Essex Club, and I shall try to get in practice
for tennis with you—you and I partners—for life—in games
and in work—oh dear Corinna, pray God it may be as we hope
and expect—true and holy and forever—
Joe.

P.S. My address is—care Joseph Sargent Esqur
Magnolia
Massachusetts.

Clara [Adelaide] May (1872–1946) was a resident of Dublin,
New Hampshire, and a favorite model of painter
Abbott Handerson Thayer (1849–1921). She married
Reverend George Lyman Payne of Boston in 1899.

Moses Soyer to David Soyer [1940]
Letter, 1 page, handwritten, illustrated
Moses Soyer papers, 1920–1974 and n.d.

Hello David—

Having a good time—so am I
Very Truly yours Bright Eyes
Dont I resemble a miniature tiger.
Love & kisses
From me,
Daddy & Mother

Moses Soyer to David Soyer [1940]
Letter, 1 page, handwritten, illustrated
Moses Soyer papers, 1920–1974 and n.d.

Dear David—

Jester is sitting on my table as I write this letter. He is playing
with the telephone wire, the books and the papers. He has grown
considerably since you left, and is awfully cute and ful of mischief.
You might be happy to know that the Giants are having a
sensational winning streak. They won six great games in succession.

Albert Sterner to Marie Walther Sterner, 6 May [1899]
Letter, 4 pages, handwritten
Albert Sterner letters, 1894–1916

Saturday 4 p.m.
May 6

My own darling Marie!

Although I have had the strongest longing to communicate
with you ever since I kissed you and our darling Bimby at parting
my condition has been such that I could not until now do so. I
have been to be quite plain more or less seasick & Thursday &
Friday I spent most of the day in my room. But my seasickness
my dear wife I assure you has not been anything in point of
severity as compared with my constant feeling of homesickness
for you & Harold & Nutley [New Jersey]! This ship for some
reason or other has seemed like a prison and constant visions of
the lovely spring and our dear little home rise up before me and
I wish myself back at your side again—But just as it is a prison,
so it is relentless the ship and speeds on its way bearing me
ever further from you and my baby! We are only making fair
progress—256. 30 lat[itude]. 30 lon[gitude]. are the sums. The
company is in no way interesting and the captain proves to be
what he looks just a seaman with little or no conversation. A
young fellow plays the violin tolerably well and we drummed
something together this morning. There is a pack of six unruly
children on board who pester every one's lives out by their noisy
behavior— The table is only fair and it has been quite cold so
that I was glad of my heavy clothes I am about half through
"Marcella" and find it fair —very padded and not too original.
To day the weather is mild and lovely—We are about 100 miles
South of the Banks. At this season we do not go across them. I
am sorry that I did not make the H___s pay me very much
more to come away from you. I feel that every body's spiteful
against me. Dont you?

Monday 10.30
A.M.

Only Monday my dear dear Spiggy and I am so terribly homesick that I don't know what to do. Never before in my life have I experienced any sensations which are like my present ones; it is as if all the world had ceased and nothing would go on until I had seen and touched you once again. I realise how much you are to me my dear dear Spiggy and I shall think a long while before leaving you for any length of time again. I have not been feeling very well since on board and although I am quite free from sea sickness now I have constant and severe indigestion caused I am afraid by the food which is not very wonderfully prepared and often causes me to think of some dishes prepared by Bertha! This journey proves to be one of the most monotonous I have ever made. This morning at 9.30 took place the burial of a young woman in the steerage who died Saturday from paralysis. It was a solemn sight to see the flag wrapped coffin given to the sea. Of course there is no news. I count the hours till we arrive and then I shall count them till I depart to go back to you and the boy! It makes me feel happy to know that there is tucked away in Nutley such a dear little place as is our home and I begin to understand the meaning of the word which has heretofore in my life been not quite plausible "Everybody still spiteful against me

Tuesday. May —
6 P.M.

To day the sea is like a pond and the ship is so steady as if in port. The weather mild and beautiful and I am glad to say that I am feeling much better than heretofore—We are expecting to get in late on Sunday in which case I shall not be able to leave Antwerp till Monday. I would give all I have and more to see you and my little love Bimbey. It is awfully lonely away from you both and with all these strangers about me I have many blue moments. The bugle has just blown for dinner which I wish were an hour later. I hope there will be letters for me from you when I get to London. I am of course most anxious to hear that you are well. I am conceited enough to think that my Spiggy is not happy when I am not there. Marcella is a fool! Millions of Love and a thousand kisses all over you both. Write me long letters.—

Thursday. 1 oclock P.M.

I am heartily sick of this long voyage my dear dear Spiggy. If you only knew how I long to have you & Harold. And you? Are you very lonely dear? I am making a drawing of the Captain who I understand is exceptionally jolly on this voyage! The drawing is not very good. It seems impossible to do anything well on board!—I found the key of my studio which I send. Hope you have not been inconvenienced by not having it. Has Miller sent out the drawings & paintings? I suppose Nutley is lovely now. I hope you are not uncomfortably warm. It has been cool all the way over! We expect to be at the Lizard Saturday morning and of course will be telegraphed from there so that you ought to have heard of our arrival (if all is well) in the Saturday paper. All in all it has been a very tiresome journey and I think for more reasons than one I shall take a quick ship back!— Lunch is ready so I must break off. Goodbye my darling Spiggy A thousand kisses.—

Bimby is Harold Sterner (1895–1976), Albert and Marie's son, who became an architect. "Marcella" may be the novel Marcella *by Mrs. Humphrey Ward (1894). The Lizard is a peninsula of Cornwall that contains the southernmost point of Great Britain, Lizard Point.*

John Henry Bradley Storrs, ca. 1914
Poem, 3 pages, handwritten
John Henry Bradley Storrs papers, 1847–1987

My soul hangs upon your
love—my lips burn to
touch your neck—your
eye —your finger tips—
to kiss each breast and
the hair that is so hot
between your legs—
to kis —to kiss each
drop of blood—as stain-
ing red it surge —
pulsing—throbing through
your heart—
I lay my lips upon
your soul -- until
 "I come"

"I come"

"I come"

Come
———
———
———
———
———
———
———
———
———
———
———
———
———
———
———
———

———
———
———
———
———
———
———
———
———
———
———
———
———
———
———
———
———
———
———
———
———

John—

In the exhibition catalog, John Storrs *(New York: Whitney Museum of American Art, 1986, p. 17), author Noel Frackman made this insightful comment about the poem: "Storrs' serious commitment to writing poetry seems to have begun with this romance. An unpublished love poem he wrote to Marguerite is significant in terms of understanding the evolution of his art toward an ever increasing purity of geometry. The poem is striking in its intense expression of passion and in the simple but revealing sketches. In a columnar series of parallel lines, sexual release is metaphorically expressed by means of pure geometry."*

Lenore Tawney to Maryette Charlton
[postmarked 26 September 1977]
Postcard, various media
Maryette Charlton papers, 1929–1998

The panda has been discovered only of late years in the mountains of India. It has been termed the most beautiful of all known quadrupeds. F. Cuvier

This beautiful creature is a native of Nepal where it is known under the different names of Panda, Chitwa, & Wah. J. G. Wood

A wife has a cow a Love Story—G. Stein
A long march begins with a kiss not a single step

a kiss a step a thousand miles

Abbott Handerson Thayer to Emma Beach, 28 August 1891
Letter, 4 pages, handwritten
Abbott Handerson Thayer and Thayer family papers,
1851–1999

Sat. Aug. 28.

My darling, my darling all the joy, (that happens to be at flood A.M. in me), health restored sleep heavy and full appetite and the sense of having possibly an actually great picture here all this I pour into your heart this morning. I have the ring diagram. There seems to be no compelling reason yet my moral sense like yours says be calm and endure gratefully one month more for a lot of little reasons About Oct. 3 I shall meet you somewhere by the sea, is it not so! and after we feel calm enough we will come here for the week or two remaining.

Oh Emma I was ever a luxury-lover it is the lively, glorious background of all our remaining lives together, reading together, seeing together, that makes this coming ecstasy an essentially calm delight—The exquisite fact that ✿ the wild bottomless carouse that my nature has so often longed for awaits me as the normal and noble gate to a noble life where we shall be eternally each others conscience in purest harmony—that this can await us near at hand with such a sequent in sight of a prospect of

poisonous regret. Blight not such bliss to pay for all possible agony on Earth—I was going to write my Addie a calming letter to help her over the time! Well I am going to paint little, (my picture is quietly getting itself done, and shoot and shoot—What a comic history of your heart! Would I had dared keep the series of letters—I threw a fire brand at Addie and she hurled it away and assured me it hadn't caught her clothes, but lo a spark did catch and in each letter behold her more and more in flames! Till I, the boy-heart am full of delirious sense of power that I could set such a fire—Let it burn down a little now but you perhaps forgive too much am yes too self indulgent in having ravished you with thoughts already? You can't say no and mustn't say yes so don't answer.
Cover the coals and we will pile on new stuff (such stuff!) Oct 4.

Alberto Vargas to Anna Mae Vargas, n.d.
Poem, 1 page, typewritten
Alberto Vargas papers, 1914–1981

To my Ana!....

I run my greedy…fever-quiv'ring hand
 'Round goddess-contour o'your Damascus Flesh..
Aye soothing touch exacting 'toxicant melody
 From your soul's clavichord, taut, laughing, fresh..

And caress your tempting lips…aye avidly,
 With my starched soul upon scalded mine,
Sun-baked, desert-thirst, to appease a-seeking
 By vivifying thrall of your kisses wine..

Oh most wanton delight, your skin's quintessence!
 Honeysuckle, amber, nectar from The bloom exotic.
And dip..sindazed, I..my embattled soul
 Twixt warm concavity o'your breasts' erotic..

Or whisper, faint sweet words o'nothingness
 In alabaster shell 'neath, damp, luxurious hair,
Your dim, tender voice distilling Lust into the brain:
 My thoughts of you – in you to loose fore'er and e'er

My Nirwana, do not flail, do not scold..but beware!..
 This passion, insatiation grim, to me, YOU..will'd!..
O'your lips having tast'd and flesh and words insane:
~~Such killing drug'll drown my crave too soon still'd~~
 Give me more of Your Killing Drug – I Shan't be soon still'd

Sarah Warner to Olin Levi Warner, 25 June 1859
Letter, 4 pages, handwritten
Olin Levi Warner and Warner family papers, 1862–1963

Gloversville June

My dear son Olin

I was much pleased with a letter which came to hand some
days since, when on opening – to my great joy I found it was
from the hand of my bsent boy, the first that my son has ever
written to his mother. I traced each line with an axious eye, for
your mother forgets not her first born – The one who coccupies
a large place in a mothers heart. my thoughts often wander to
the place where we believe you are trying to get an education and
we feel quite sure you will try to improve the precious hours God
gives you, as als to appreciate the labor bestowed upon you by
your kind and very endulgent friends, I mean your dear – uncle
and aunt. Were it not for their endulgent and affectionate regard
certainly you could not be there. You who have not the means to
educate yourself ~~with~~ could not expect so great a privilege as you
enjoy this summer, only through their kindness.
And I sincerely hope your waking hours will be so well improved
that the hearts of your parents will be gladened, as als your kind
friends who bestow so much labor upon you, and in future if
your Father in heaven should permit you to live you will be able
to make satisfactory returns to them, for this labor and kindness.
Try in every possible way you can to make yourself useful to
them remember you must not forget to help in looking after the
children when your aunt wants your assistance and always be very
kind. If I remember rightly, you are not very fond of children, but
you must never tease them, you must learn much patience with
little <u>folks</u>, for you were little once, yourself and I realy think you
will. I have some anxiety about that old habit of teasing, hope
now you will begin to overcome it.

Friday morn finds me again seated at the table to finish up an
unfinished letter, company has called me away, but once more
alone and I will try to finish up our silent talk. I would be very
glad to see you and talk face to face, but I must wait.
You write me, that "you are getting along finely" in your studies.
I am very much pleased with the good report you give, but you
did not tell me what studies you were taking this term, "<u>No bad
markes</u>." This encourages your Father as well myself very much.
We think you are trying hard to improve your time we hope not
to the injury of your health. You must take much exercise in the
open-air when you can spare the time. Your Aunt Eliza if well will
soon visit you and I want you to write immediately informing me
what you need for summer clothing, as I would like to send
something by her. She goes next week or one week after if Aunt
Laura is well enough to leave. Your Father since his return to
Gloversvill visited Rockwood spent one sabbath with them
found our good Mother Orton just dead from an attack of
inflamation of the bowels sick one week –Grandmother Jeffers
was buried last april, also the grandmother of Hedding Putnan.
Mr. Shaw the blacksmith is just alive with dropsy. Pleasant valley
has changed very much, Father Orton is broken up and now
lives with his son Lorenzo the good old Lady often spok of you
and desired to see you and your father but she has left this
world of sorrow in a good old age. She died rejoicing in Jesus as
her only sure trust in the dying hour. She had for years been
trying to trust in the Redeemer and he forsook her not in death.
The whole of Rockwood mourns for her. She was greatly
beloved. Precious friend to you, to us all. We can only visit the
spot where those sacred ashes lie, and write Farewell over the
dust of her we loved, and leave her to sleep on, till God shall
wake the sleeping dust. May you my dear son ever remember
the good advice which she gave you and early begin to love the
Lord, fearless of all the opposing influences around you, give
that young heart every day to God. Pray to be kept from evil
influence around you. Remember your mother prays much for
Olin. Present my choice love to your Uncle and Aunt, love to
German Libby also. Write immediately giving all particulars.
Father joins me in love to our absent boy
Your affectionate mother S. Warner
Melville wishes to be remembered to his brother, he is attending
school just now. He began a letter to his aunt 2 weeks ago but
has not finished.
S. W.